# The Persistence of Myth and Tragedy in Twentieth-Century Mexican Art

*Selections from the collection of Robert B. Ekelund, Jr.*

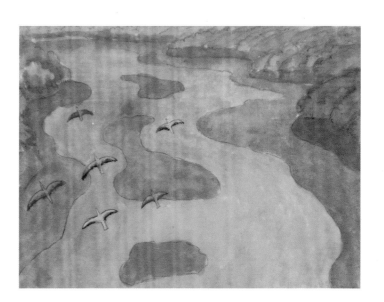

COLORADO SPRINGS FINE ARTS CENTER, Colorado Springs, Colorado

IN ASSOCIATION WITH

THE JULE COLLINS SMITH MUSEUM OF FINE ART, Auburn, Alabama

Published by the Colorado Springs Fine Arts Center,
in association with The Jule Collins Smith Museum of Fine Art
at Auburn University, Auburn, Alabama.

Colorado Springs Fine Arts Center
30 W. Dale Street
Colorado Springs, Colorado 80903
719-634-5581
www.csfineartscenter.org

The Jule Collins Smith Museum of Fine Art
Auburn University
901 South College Street
Auburn, Alabama 36830
334-844-1484
www.julecollinssmithmuseum.com

ISBN 0-916537-13-7
Library of Congress Control Number: 2004108672

This catalogue was published on the occasion of the exhibition *The Persistence of Myth and Tragedy in Twentieth-Century Mexican Art: Selections from the Private Collection of Robert B. Ekelund, Jr.*

COVER: FRONT — Diego Rivera, *Yucatan*, 1930-1931, watercolor on rice paper, 12 x 16
        BACK — Diego Rivera, *Sueño*, 1932, lithograph on paper, 16 x 12

ALL PHOTOGRAPHS (except Figures 11, 17, and 18) are by Greg Strelecki

EDITED BY: Toni Knapp

DESIGNED AND PRODUCED BY:
Boulder Bookworks, Boulder, Colorado, www.boulderbookworks.com

Printed in Canada

# EXHIBITION SCHEDULE

COLORADO SPRINGS FINE ARTS CENTER, Colorado
September 4 – November 21, 2004

THE JULE COLLINS SMITH MUSEUM OF FINE ART
at Auburn University, Auburn, Alabama
April 1 – May 22, 2005

MOBILE MUSEUM OF ART, Mobile, Alabama
June 24 – September 4, 2005

# CONTENTS

# ILLUSTRATIONS

# ILLUSTRATIONS

*In memory of*
*Anna Mae*
*LeBlanc Ekelund*
*who, in 93 years,*
*never lost wonder*
*for beautiful things.*

# FOREWORD

$\mathcal{I}$ met Bob Ekelund approximately three years ago, shortly after I came to Auburn University to head the Department of Art. I still remember the first time I visited his home. From the moment I walked through the front door, I was surrounded by art—and not just any art. A half-dozen or more large Rouault prints were in the dining area; from there, I walked from room to room and was overwhelmed by the breadth and depth of his collection. But it was his Mexican art that made the strongest impression. It seemed truly encyclopedic, containing works by all of the acknowledged masters. The collection that I saw was more than a survey; it contained some absolutely stunning paintings, drawings, and prints, and two wonderful pre-Columbian sculptures. Only once or twice in my life have I been this excited upon seeing a private collection of such scope. I could easily list my favorites, but I don't want to influence your own experience with the works displayed. By any standard, the collection and the selections from it that form this exhibition are outstanding.

The exhibition—*The Persistence of Myth and Tragedy in Twentieth-Century Mexican Art*—is the fourth in a series of exhibitions mounted by The Jule Collins Smith Museum of Fine Art at Auburn University. Conceived by the museum's first director, Dr. Michael De Marsche, the series highlights the private collections of members of the Auburn community—faculty, alumni, and friends. These exhibits present collections that have rarely, if at all, been seen

by the public, and illustrate the unique vision of the individuals who have assembled them.

I am pleased that we are joined by two distinguished art museums in presenting this exhibition to the public: The Taylor Museum at the Colorado Springs Fine Arts Center, and the Mobile Museum of Art.

I want to extend special thanks to Catherine Walsh, Curator of Exhibitions at The Jule Collins Smith Museum of Fine Art, for her work in organizing this exhibition and working with Robert Ekelund on the catalogue essay. The staff at the Taylor Museum has done an excellent job of producing the exhibition catalogue.

This exhibition provides a glimpse into a world unknown to many of us. It is a delight to the eyes and the imagination, and is as educational as it is inspirational.

JOSEPH ANSELL, Ph.D.
Interim Director
Professor and Head,
Department of Art
Auburn University

# PREFACE

*R*arely is it possible to clearly identify the origins of particular traditions in art. The complex art produced in Mexico in the twentieth century may be an important exception. It was not until the "popular prints" of José Guadalupe Posada (1852–1913) that the origins of a truly *Mexican* art could be identified. Pulling together never-ending traditions of tragedy and myth exemplified in the folk arts of Mexico, themselves built on pre-Columbian and Hispanic influence, this humble printmaker established a foundation for an art of incomparable beauty, socio-political concern, and mythical spiritualism. The great painters of the first half of the century, Diego Rivera and José Clemente Orozco in particular, were directly influenced by Posada. It is well known that elements of the *Mexicanidad* movement, including an emphasis on mural painting, were rejected in and even before the second half of the twentieth century. And, while contemporary European and North American "isms" were also being absorbed, a unique quality in addition to individual artistic creativity—a quality emphasizing tragedy and myth—remained.

This exhibit seeks tentatively to explore those traditions with examples from 22 artists, such as Posada, Rivera, Orozco, David Alfaro Siqueiros, Rufino Tamayo, Leonora Carrington, José Luis Cuevas, Francisco Zuñiga, Rudolfo Nieto, and Alejandro Colunga. These and other great Mexican artists are shown to be parts of an ever-enriched art that, while international in appeal and recognition, carries the unmistakable stamp of unique millennial influences.

# ABOUT
## THE COLLECTOR

*I* was born and raised on Galveston Island in Texas. My lifelong interest in art and music—both in practice and appreciation—began as a young child and was fostered and encouraged by both of my parents. I began piano lessons at the age of six and later studied with Silvio Scionti, founder of the North Texas State University School of Music. My interest in the arts led to some painting and printmaking at the time. This and intense reading in art history, along with an introduction to Mexican culture through a high school friend, were formative influences even before I went to college.

I lavished attention on as many courses as possible in the history of art at St. Mary's University, where I ultimately received bachelors and masters degrees in economics. While a student there, my particular interests in twentieth-century European art were greatly stimulated by a spectacular teacher, Dr. Peter Guenther. Proximity to Mexico, with its border barely two hours from San Antonio, added to an appreciation for that country's arts and cultural heritage, including early interests in tequila, bullfights, and Mexican beer (before it was popular).

I received the Ph.D. in economics at Louisiana State in 1967 and returned to Texas to teach at Texas A&M University. I remember so vividly the destination of one of my first paychecks. A traveling week-long exhibit was featuring some prints by Braque, Picasso, and other European artists. My passion for a small print by Picasso led

me to spend most of my monthly salary on it. Missed meals were a small price to pay for that print, one that I treasure to this day. Long summer trips to various parts of Mexico over the 1970s again stimulated an academic interest in the Mexican popular and fine arts. The resplendent treasures of pre-Columbian and modern art of Mexico City and Cuernavaca were particularly enchanting. But my collection of post-impressionist works on paper continued.

In 1979, I became a permanent member of the faculty of economics at Auburn University. My academic interest became a collecting obsession after a visit to California in the late 1980s and further encounters with the art of Mexico. I find that the color, form, and subjects of that art reveal an acute involvement with the fantastic facts of life and death, and with tragedy and myth. Moreover, these artists make little or no attempt to disguise an intensely passionate view of *all* of the elements of the human condition— the beautiful and the horrific. I have, for almost two decades, been obsessed and enchanted with these artistic confrontations. That obsession was fostered and enlarged through contact with Michael De Marsche, founding director of The Jule Collins Smith Museum and now president and CEO of the Colorado Springs Fine Arts Center, who suggested and encouraged this exhibit. My debt to him is great and I believe that my obsession will continue.

ROBERT B. EKELUND, JR.

Catherine L. and Edward K. Lowder Eminent Scholar in Economics (Emeritus) and founding advisory-board member of the Jule Collins Smith Museum of Art at Auburn University.

# ABOUT
# THE COLLECTION

*T*he Ekelund collection of Mexican art began in earnest with a visit to a San Francisco gallery in late 1980s. There to purchase a small Picasso etching, Robert Ekelund could not take his eyes off a brilliant pastel drawing of four Mexican women on the way to market. Zuñiga's *Camino al Mercado* (1984) became the foundation of an ever-expanding collection of Mexican art. Shortly after this purchase, Ekelund decided to engage in self-education into the whole skein of twentieth-century Mexican art that, when he began collecting, had already become quite popular. In 1977, Sotheby's auction house (New York) began conducting semi-annual auctions dedicated exclusively to Latin-American art, and Christie's (again New York) followed suit in 1981. Together with contact with other collectors and with specialized galleries in such far-flung places as Santa Fe, Los Angeles, New York, Toronto, New Orleans, and San Antonio, they created ready sources for Ekelund's "education."

Essentially, Ekelund began looking backwards and forwards from Zuñiga's work, acquiring original works by Rivera (*Yucatan*, 1930, *Forest, Tehuantepec*, 1928), Orozco (*Female Nude*, 1946) and Siqueiros (*Nostalgia for Liberty*, 1966). Simultaneously he was developing an extensive assemblage of graphics from artists of the *Taller de Grafica Popular* of the 1940s and 1950s and earlier ones by Rivera (including his beautiful *Sueño*) and Orozco. Works in the romantic tradition of artists such as Corzas,

Casteñeda, and Guerrero-Galvan were also added to the collection. Posada's drawings from the turn of the last century and works in the "art of the fantastic" by contemporary artists Colunga and Nieto, were acquired in order to provide understanding of the whole span of the twentieth century. One of the unifying aspects of what was becoming a "survey" was, as in the title of the current exhibit, a search for myth, tragedy, and politics in the art. At base, the collection attempts to demonstrate these elements in art executed as sculpture, oils, drawings, watercolors, and in pre-Columbian and folk art as well. That quest continues.

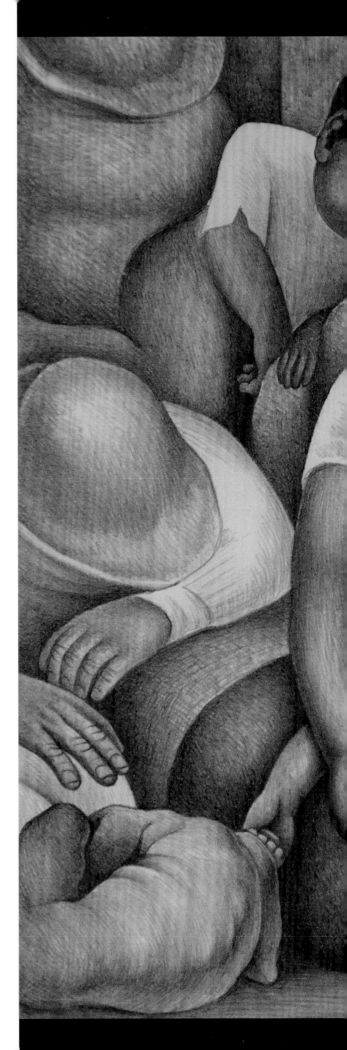

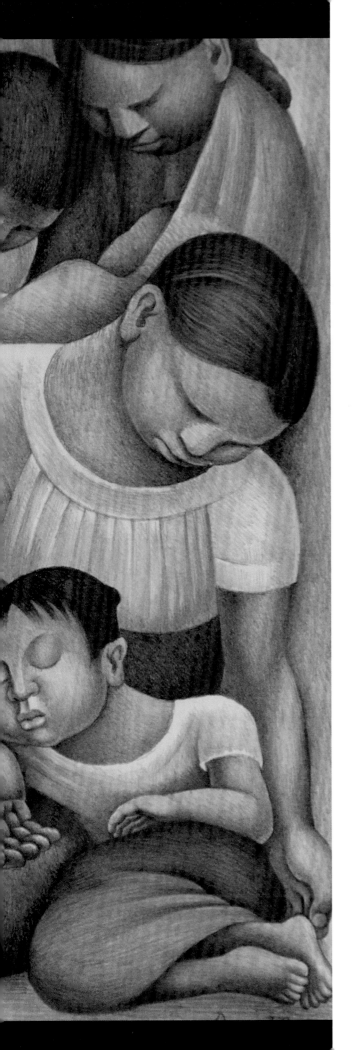

# The Persistence of Myth and Tragedy in Twentieth-Century Mexican Art

Robert B. Ekelund, Jr.
and
Catherine Walsh

$\mathcal{A}$ PARTICULAR VIEW OF LIFE— one emphasizing the power of myth, tragedy, and beauty in culture—is a hallmark of twentieth-century Mexican art that persists to this day. Unlike other major cultures and the religions they produced, the isolated pre-Columbian "Mexicans" did not graduate to a scientific or philosophical means of dealing with risk, human fear, and the vagaries of nature. While these great cultures made clear strides in astronomy, mathematics, and language, there was no "Renaissance" or scientific revolution sparked by confrontation with other cultures (Greek, Eastern, Arabic) as occurred in Europe. Further, Mexican culture and society, while making great strides in the modern age, has never fully extricated itself from these kinds of internal preconceptions. The well-known Day of the Dead (*Dia de los Muertos*, November 2), along with its mythological and magical accouterments, however integrated with Christian holidays, is only one example of a preoccupation with pre-Columbian fixations. The entire attempt to create a unique Mexican identity from the disparate strands of evolved indigenous and Hispanic culture in the twentieth century must be associated with facts of Mexican cultural history.

Pre-Columbian culture, like all of those that have followed it, was typified by a highly skewed income and wealth distribution with *indios,* indigenous native Mesoamericans, and later *indios* and *mestizos,* intermixtures of native Mesoamericans with European and African bloodlines, at the bottom.[1] Pre-Columbian and Spanish monarchs, and later dictators and "strongmen" created and enforced this distribution. The long-suffering poor "made do" as their descendants have. But these cultures— inculcating a persistent and pervasive fear of imminent disaster and retribution—produced descendants filled with angst, pessimism, fear and fatalism in written, but mainly, oral history. As historian T. R. Fehrenbach put it: "Mesoamericans looked back to a calamity-filled past to discern their future. Priests, magicians, and fortune-tellers abounded, and even the most intelligent and rational people studied all natural

---

[1] All of these people, indigenous, Hispanic, African, and all racial mixtures are of course "Mexican" if they live or *lived* in that area called Mexico today. But "Mexican" is more than a geographic description. In this essay, the term "Mexican" most often refers to the identity of all those populations as it came to be understood in the twentieth century. Further, the term *indios* or Indians is used to identify the native portion of that population in both pre-Columbian and modern times.

phenomena for portents or omens. The superstitious emotions of the masses were easily aroused, and the rulers, though just as superstitious, tended to be fatalistic."[2]

A fatalism integrating myth and the philosophical preconceptions of both pre-Columbian and post-Conquest Christianity sets the stage for this exhibit of twentieth-century Mexican art. A long and continuous attempt to humanize and tame death and to establish a connection to life, enlivened by a tumultuous political history, is exemplified in the folk art, high art, and culture of modern Mexico. No matter the exogenous influences or "isms" on twentieth-century Mexican art, these influences manifest themselves. At least a cursory background is necessary to fully understand this magnificent art.

## The Origins of Mexican Art

All art begins with sentient humans and their quest for permanence and the eternal—a quest that is never-ending. Nowhere is that connection more pronounced than in the unfolding Mexican art of the twentieth century. Animism and magic pervaded the earliest truly human societies.[3] Some means had to be found for keeping chaos at bay; that is, early humans had to devise a means of defining existence and its conditions as an element of survival. A proclivity for myth is premised, at least in the standard anthropological formulation, on a desire to explain the obvious fact that humans are mortal *and* that this mortality is closely linked to the everyday problems of survival.

Early *Homo sapiens* (and possibly other species), with salient mental "operators" of cause and effect, created forms of magic and belief, including fertility cults and death ceremonies to this end in virtually all regions of the world. Animism was the natural form of myth-making among these

[2] Fehrenbach, *Fire and Blood*, 102.

[3] Animism is a term admitting of both narrower and broader definition. In a narrow interpretation, animism is some attribution of conscious existence and attributes to some natural object—a bison, bear, tree, or stone. Belief in devils or in ghosts, spiritual beings separable from their corporeal bodies, is another form of animism. In the broadest context, religions holding that an immaterial force motivates or animates the universe may be termed animistic. The latter belief may be primitive in nature (for example, gods demanding human sacrifice as propitiation for sunshine or crops) or sophisticated, relying on abstraction or philosophy as a condition for existence. Animism may be used as an unseen operator.

early hunters as deer, bison, and other food sources were the keys to survival. The development of artistic and musical forms was integral to this development. Carvings or paintings of animals or human effigies were thought to have magical power to, for example, heal the sick or produce a fruitful hunt or rain. Cults surrounding animal worship undoubtedly arose with particular rituals attached, including familiar ones—familiar in present-day animistic practice or recreations—such as the wearing of skins and incantations to attract food sources.

Such methods of survival spread worldwide and, most likely, to the Americas by 25,000 years ago. The manner of human survival changed, perhaps gradually, with the domestication of plants and animals about 12,000 years ago spreading from the Middle East throughout all of Europe and to the Americas as well. While societies were "mixed" for a time, settled agriculture began to dominate, creating new forms of art, magic, and survival traits within the body human. It is at this point in human evolution, where populations were sedentary, that religion and the art to which it is related began to evolve into organized moral codes from the more elemental forms of myth and magic. Religion, also appealing to supernatural forces (a god, divine mover, eternal spirit), may be regarded as an ongoing system of myths, beliefs, values, and practices based upon some spiritual leader or system of principles.

Use of some intermediary may have resulted from the failure of magic to have empirical content, that is, to work in some predictable, demonstrable fashion. Some scholars characterize religion as, in crudest forms, attempts to influence powerful spirits with sacrificial gifts. Even in hunter-gatherer societies there is evidence of some kinds of propitiation or sacrifice to deal with the everyday necessity of survival. It is generally believed, however, that religion as an organized, appeasing force to obtain favors from powerful gods originated in settled agricultural societies. According to these definitions, neither magic nor religion has ever been absent from any known society. In early forms of religion, human or animal sacrifice, dance, art, music, and a myriad of other forms of propitiation were used to placate "the gods."

The origins of all art, Western, Eastern, or pre-Columbian, must be understood within this perspective. The ancient gods and goddesses of these cultures—those that

[4] Music may have emerged as a by-product of art and religion. The positioning of the spirit caves depicting animals at Lescaux and other locations of Europe may provide examples. Prehistoric rock art may have been positioned so that there was an "acoustic impact" on viewers. Reverberations caused by clapping, the sound of hooved animals or possibly primitive instruments, may have suggested that the spirits were "talking" to worshipers in a kind of audiovisual manner. See Saunders, *Discover*, 13.

were attributed magical powers and who, contractually, had to be appeased—clearly shaped the nature of art in those and subsequent times.[4] Pre-Columbian artists were thus influenced by external and historical factors and also by elements internal to a particular artist's vision. Fertility cults, death rites, earth mothers, gods and goddesses related to fire, the moon, the sun, and all manner of other elements are, unsurprisingly, common to most early societies. Within this common heritage, however, much variation existed.

Critical differences existed in the nature of religious contracting and in the degree of power invested in particular deities: Western and Eastern pantheons of gods, while focusing on survival and an afterlife, contained strong elements of love and forgiveness, while the gods of Mesoamerica were essentially monstrous or menacing deities, demanding radical and ultimate forms of propitiation and sacrifice. Although cultures such as the Egyptians focused on death and an element of death ritual in their mythological pantheon, a death cult with *regular death sacrifice* as propitiation typified much

of pre-Columbian civilization from its beginnings up to the Spanish Conquest, especially in the final pre-Columbian period called *Aztec* or *Mexic* (AD 1000–AD 1521).

The Mesoamerican cultures of Mexico adapted a unique form of philosophical dualism and a cyclical rather than a linear view of time. In this view, time "deteriorates" at night and is "reborn" every day. Priests in their universal role of "keepers of the calendar" transmuted this daily cycle into a calendar of astronomically determined seasons wherein nature "dies" in winter and is reborn in spring. At each point in the cycle, gods of the sun, moon, and rain and of time and creation, embodied in the serpent-plumed god, Quetzalcoatl, had to be satisfied with all manner of sacrifice, predominately human sacrifice.[5] In Mesoamerican theological beliefs, sacrifice of this kind was necessary continuously to reestablish equilibrium between life and death.

Cultures emerged and disappeared in these horrifying theocracies held together by priestly and militaristic aristocracies. Deadly ball games, where the losers were killed in ritual fashion, were blood sport. Captives from warring tribes were slaughtered en masse with beating hearts pulled from their bodies and placed in specially carved containers. Archeological evidence

[5] Quetzalcoatl was the central god of pre-Columbian mythology. He was the lord of life and death and took on multiple attributes. As one writer explains, the very name "seems to be a symbol of man's condition and of his possibilities. . . . [he] was a composite figure describing the many orders of matter in creation: a kind of ladder with man at the center, but extending downward into animal, water, and mineral; and upward to the planets, the life-giving sun, and the god creators," (see Irene Nicholson, *Mexican and Central American Mythology*, London: Paul Hamlyn, 82).

has uncovered the mass graves of children and infants sacrificed during times of turmoil, scarcity, and drought. The population viewed the whole world through a prism of religious and magical ideologies. Complex rituals and ceremony replaced the "rough magic" of the earliest period and major god-forms became universalized throughout Mexico. The "classic period," originating from the Olmec (1500 BC) culture to about AD 1000, produced beautiful art, however horrific in the main and even more spectacular architecture. The Maya, Totonac, Zapotec, Huaxtec, Tarascan, and Teotihuacán cultures flourished throughout Mexico, loosely aligned as a "Mexic society" that basically imitated the earlier and more fecund artistic periods.

Not all early art was horrific in nature. The animistic preconceptions of early west coast cultures, Colima and Nayarit in particular, produced beautiful, often quasi-abstract, and mysterious images. Animals of all kinds played both a practical and a magical or spiritual role in the death and burial rituals in Colima culture, for example. The plump dog especially was considered, variably, to be "food for the dead" and/or the deceased's guide to the land of the dead along subterranean rivers in "tomb cults." Many examples exist, some with human faces on the dog's body, and either built into the terra cotta or attached as a human mask. These dogs, called *izcuintli*, were also used for symbolic food and were, in life, considered a delicacy. The pup (see FIGURE 1, page 23) in this exhibit has pointed perky ears and nose, and a slightly crooked grinning mouth.[6] Most pre-Columbian sculpture is horrific in nature, however, or even directly related to the death cults.[7] Some of the art was created to be decidedly functional as well as religious. Along with flutes and primitive drums, rattles and whistles were used in ritual religious ceremonies.

For the most part, however, pre-Columbian art depicted the monsters that were enshrined in pantheons of gods and goddesses, some of them local in nature.[8] Periods of internecine warfare emphasized the militaristic nature of the various societies. West Mexican terra cotta figures of warriors or players in the sacred ball game called *pelote* appeared. Warriors, wielding clubs, wear a protective helmet and padded protective gear. It should be noted, however, that pre-Columbian art was also often

[6] All references to works in this exhibit that are not followed by a plate or figure number are included in the Exhibition Checklist.

[7] One of the most fearsome gods of all pre-Columbian mythology was Xipe–Totec, the god of spring and renewal. At the spring "celebration," the skin of a victim would be flayed and the skin would be fitted on a young impersonator of Xipe. A twenty-day ritual in honor of the god would follow and like the tender shoots of a new plant, the rotted skin would fall away and a "new" (young) human would emerge.

[8] The Gulf Coast Mayan god, Hurrucan, for example, from which the word "hurricane" is said to derive, is an example of a localized deity.

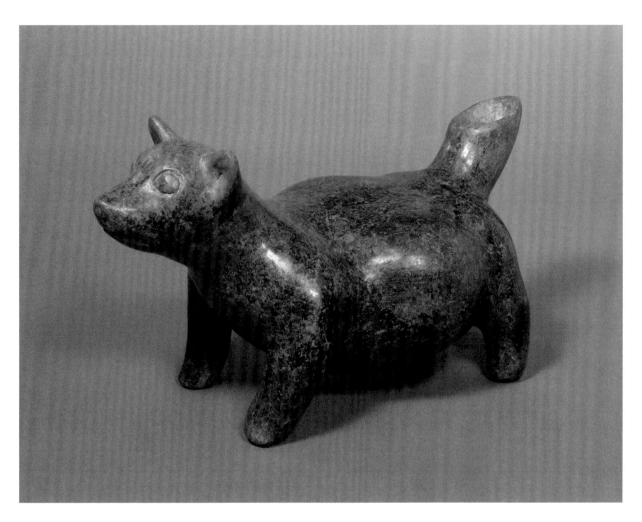

**FIGURE 1**

*Pre-Columbian Dog Effigy*, c. 200 BC–AD 300

Molded terra cotta

Colima Culture (West Coast)

7¼ h x 7 w x 12¾ d

personalized and even depicted deeply com-
mitted couples. Some sculptural forms
depict tender domestic scenes that may have
been placed in a tomb as a burial effigy.
Some figures, frequently repeated, show
couples embracing in representational ren-
derings. But scenes of domestic tranquility
were relatively rare in the total *oeuvre*.
Magic and mysticism was present, but
unlike that of contemporaneous European
culture, the pre-Columbian world never
graduated into the use of scientific or philo-
sophical methods of dealing with uncertain-
ty and the vagaries of nature. Further, the

Mexican culture has never totally gotten
past these mythological preconceptions. It
has a romance with death and with the
tragic view of life. Just as a child's monsters
are made an object of ridicule, death is an
enemy that must be made a friend.

## Christianity and the Spanish Conquest

*T*he tragic nature of Mexican cultural and artistic preconceptions did not diminish greatly, but merely changed directions, with the arrival of Cortes in Vera Cruz (on April 21, 1519) and the Inquisition-inflamed brand of Catholicism the conquerors brought with them from sixteenth-century Spain. Montezuma II (AD 1466–AD 1520), the last Aztec emperor of Mexico, was expecting supernatural creatures just at this time due to a tenet of pre-Columbian mythology. But he was soon a slave and the *indios* were soon conquered. With Indians forced to become Christian, the blood-soaked pre-Columbian altars fell into history. The artifacts of a rigid Spanish Christianity were installed and a culture of thousands of years was soon demolished. Friars burned the sacred books (codices) of the Maya and other cultures with a zeal

they had learned in Spanish book burnings, severely curtailing history's understanding of a great and ancient civilization. Fundamentally, one theocracy replaced another.

The impact of the Spanish Conquest and Roman Catholicism on Mexican art, religion, and culture can hardly be minimized. The combination of European Christianity and the law, customs, and culture that the Spanish introduced into pre-Columbian civilization has literally made Mexico a unique "Mexican" culture reducing but certainly not eliminating pre-Columbian preconceptions. A long evolution ensued from this clash, producing the unique and particular mix of contemporary Mexico. While small minorities of Indians remain, the majority of the population is a mixture of Indian and European blood-lines (*mestizos*). This long and bloody transformation of culture had political and historical consequences highly relevant for twentieth-century Mexican art and culture. A number of features of this period are critical.

The Spaniards brought with them a theocracy that mirrored that of sixteenth-century Spain, then undergoing a virulent Inquisition with Jews, Muslims and, eventually, Protestants as targets. The Church supported them and was a critical underpinning of the aristocratic Spanish government. Practices such as high taxation to finance opulent aristocracy, monopoly grants to the Spanish court's favorites, little or no public support or investments in education (almost exclusively the prerog-

ative of the clergy), and high illiteracy persisted. These practices led to immense poverty for the vast majority of Mexican people. Later, in the period after Spanish colonial domination, these factors created much political instability. This basic social structure existed under one or another form in both pre- and post-Conquest of Mexico and led to a distribution of income that, even by contemporary standards in the poorest countries of the world, would be skewed in the extreme. During the Spanish colonial period and after it, even after independence, the *indios* and large parts of *mestizo* populations of mixed Indian and Spanish blood were mainly illiterate and mired in poverty. Although the starving masses often rebelled, Mexican income and wealth distribution began slowly to change only after the Revolution of 1913–1917.

The history of Mexico from the Conquest to the present is punctuated by a battle to change income distribution and to establish a tripartite government and the kind of federalism that functions as a working democracy. In this realm, Mexican history is filled with villains and heroes. While the upper echelons of the church supported static, autocratic regimes, lower-level prelates close to the poor developed and led important reform programs. Miguel Hidalgo (1753–1811) and Ignacio Allende (1779–1811), priests of the Roman Catholic Church, are nineteenth-century heroes of early peasant uprisings (1810–1811). Both were killed by dictatorial-aristocratic forces for their troubles in support of the poor,

but revolutions and counter-revolutions continued to punctuate Mexican history throughout the nineteenth and early twentieth centuries. Losses of Texas and California—the northern states of Mexico—along with wars and disputes with the United States and a brief French occupation sapped Mexico of territory and strength in the nineteenth century. Dictators came and went, as did serious and important reformers such as Benito Juarez (1806–1872), the much-revered "Lincoln of Mexico." The period between 1867 and 1911 was an important one for establishing Mexican trade and for the exploitation, mainly foreign, of Mexico's vast natural resources. The Roman Catholic Church's influence over education and government in the country diminished markedly.

At the turn of the twentieth century, much of Mexico remained mired in poverty. Foreign investment by businesses from North America, England, and other countries meant that large portions of "profits" were exported or were spoils of corruption. Illiteracy continued, and the country was ruled for nearly 30 years by a despot named Porfirio Diaz between 1884 and 1911. Over this period, called with no affection the "Porfiriato," land "reforms" were enacted that, in effect, destroyed the traditional property rights of the *indios*. The Juarez

government, which ended in 1871, embarked upon secular education reforms, but this relatively small effort was not continued under the ensuing dominance of Diaz and others who followed.[9]

Diaz, who sincerely believed that economic development could be carried out by permitting foreign firms to exploit Mexico's natural resources, was simply mistaken as things turned out. Effective political institutions of democratic capitalism and a separation of powers along with the existence of an entrepreneurial middle class—factors that would have contributed to the Mexican economy—simply did not exist in Mexico. The mass of the population remained poverty ridden and illiterate with perhaps more than three-quarters of the Indian population and more than half of the *mestizos* unable to read or write. These conditions resulted in movements stressing further and more socialistic land reforms, education reform, rejection of "foreign exploitation," and a strident anti-Catholic, anti-clerical attitude amongst reformers and their followers. These general features of the culture were worked through all manner of styles and "isms" in the ensuing decades.

## José Guadalupe Posada and the Beginnings of Mexican Art

The "Porfiriato" and all that went before, including the spectacular creations of pre-Columbian civilizations, Spanish baroque art and architecture, European influences, and cultural, historical, and sociological factors of all kinds set a stage for the art of Mexico in the twentieth century. But until the late nineteenth and early twentieth centuries, no art that captured the evolving and complex *Mexican* identity as it existed circa 1900 had been created. With the smallest number of exceptions, art created in Mexico

[9] Juarez was a true national hero and president of Mexico from 1861 to 1863 and from 1867 to 1872. He took part in the revolution that overthrew the Mexican general, Antonio de Santa Anna (who had seized the national government in 1853). He became a champion of civil reforms including the reduction of the civil influence of the Roman Catholic Church by confiscation of Church properties. The chaos of civil war caused Juarez to suspend loan payments to France, Spain, and Great Britain. Although he reached agreements with the latter two countries, France invaded Mexico and Napoleon III installed Maximilian as an emperor of Mexico City, an arrangement that lasted only between 1864 and 1867, when Maximilian was deposed and assassinated.

in the nineteenth century was derivative of academic European traditions, especially those related to Spanish baroque ecclesiastical art.[10] All of that changed with the work of a humble genius from Aguacalientes who lived (born 1852) and died (1913), in the poorest circumstances imaginable. The Protestant Reformation had its Cranach the Elder and Albrecht Dürer, France had its Honore Daumier, and Spain its Francisco Goya. But Mexico had José Guadalupe Posada.

Posada was born into agrarian economic poverty, but the cultural traditions of Aguacalientes were far from poor.[11] Beautiful ceramics and textiles (still produced there) together with strong pre-Columbian traditions must have provided inspiration for the young Posada, as did the posters of the traveling circuses so ubiquitous throughout Mexico. There is little evidence that Posada received any kind of formal education in art and he is largely regarded as self-taught. Most importantly,

perhaps, the endless traditions of folk art continued unabated—with color, form and textures pregnant with indigenous traditions of the common people that proceeded generation to generation from the pre-Columbian era. (Academic traditions dominated the "high art" of Mexico's aristocracy as mentioned above). Just as Catholic missionaries were unable to purge completely the forms of pre-Columbian spiritualism and religion from the Indians, folk art traditions retained ancient themes.

Posada, playing off these and many other themes, translated all of these elements into what can only be termed an invention of a truly *Mexican* art. Throughout his life, Posada presented and developed his work in artisan (rather than artistic) fashion. It was a great art nonetheless. First, he apprenticed as a lithographer at a local weekly newspaper, *El Jicote* in Aguacalientes, which later moved to Leon. The themes of Posada's early work were, as they always would be, political caricature and commercial advertising. The great floods in the city of Leon in 1887 forced Posada to Mexico City where he very quickly became a popular printer. Soon he was employed at the Antonio Vanegas Arroyo Publishing House which, in addition to other work in Mexico City, Posada continued to the end of his life.

[10] The Spanish academic style is represented from the Conquest into the twentieth century. Painters such as Juan Gonzalez (active 1680–1700), for example, created academic allegories of the Ten Commandments. An early U.S. visitor to Mexico, Conrad Wise Chapman (1842–1910), who was trained in Italy, painted battle scenes of Maximilian's troops and Juarez's army in a highly academic style. There were important exceptions. José Maria Velasco (1840–1912) and others, although steeped in academic classicism in training, were important teachers and painters who pointed the way to a "Mexican" style.

[11] Additional biographical information on Posada may be found in the Introduction to Roberto Berdecio and Stanley Appelbaum (eds.) *Posada's Popular Mexican Prints.*

There are said to be more than *20,000* prints by this genius, the largest number of which were produced in connection with Arroyo's print shop. Posada had mastered lithography, type metal, and wood engraving before coming to Mexico City, but in the mid-1890s he introduced zinc etching into his methods. Posada's liberalism and loyalty to the downtrodden classes led him to create biting and original caricatures against the Diaz regime. Part of his enduring legacy was to have turned the symbolism of death into a metaphor for social reforms and murderous dictators, as well as comic relief. The *calaveras* (literally a skull or skeleton), which was undoubtedly part of the folk-artistic lexicon for many generations, became the protagonist or the one skewered in a brilliant series of prints. Social reforms, political corruption, foreign colonialism over Mexico's resources, and the "airs" of the ruling classes were all subjects of Posada's works. Devils, evil clowns, insane women, tragic and gory events of the day—with special emphasis on sensational murders—were also common. These depictions were all connected to the transmission of information to the lowest and poorest classes. With illiteracy at extraordinary levels, information and entertainment had to be obtainable in "broadsides"—prints and text reproduced on single sheets of cheap and affordable paper—that were short on text and long on illustration.

Other means of information transmission were captivating and effective vehicles for Posada's art. Dramas and songs (*corridos*) were methods of producing both entertainment and information to a semi-literate public. Stories for children were part of his repertoire. *Corridos*, in particular, told of the universal themes of unrequited love, good, evil, suffering, despair, and revolution. The Posada prints in this exhibition involve these themes. Posada both illustrated dramas and morality plays and created posters advertising them. *El Testerazo del Diablo* (*The Devil Butts with his Head*) is an illustration for a one-act morality play, whereas *Don Perabel* is a book cover for a mythological story illustration. Death and the threat of evil and the devil are obviously featured in these and many other of Posada's drawings—created from the folk art and literature of a Hispanic and pre-Columbian past. The Aztec skeletal gods and the *memento moris* of European Roman Catholic tradition are all recalled in this work.

Children's stories, many in serial form, and writing books are also represented as in the *Mexican Clown* (FIGURE 2, page 29), a children's story or writing book. This illustration of a clown, with what can only be termed a demonic expression on his face, has been a staple of Mexican art since Posada (see, for example, the contemporary artist Alejandro Colunga's demonic clown, *El Enano,* in FIGURE 23 on page 70). Diego Rivera's and other twentieth-century

Mexican artists' renditions of clowns, and particularly the great Mexican clown Cantinflas, are clearly derivative of this theme.

Love and love lost is of course a staple of music in all cultures. *Morir Soñando* (*To Die Dreaming*) is a beautiful and romantic Posada illustration of a collection of songs published by the Arroyo Company. The clarity of line, the artistic use of positive and negative space and, above all, the compositional qualities obvious in the smallest detail mark Posada's work as a seminal point in Mexican printmaking. It was to have a long and illustrious history. Most importantly, however, Posada's work constitutes the origins of distinctively twentieth-century Mexican art. This art eschewed academic traditions and, while absorbing the Mexic and Hispanic styles as translated through the "art of the people," had a life and identity of its own. This man, a self-taught artist given a pauper's burial in 1913, is universally recognized as having been the real and identifiable progenitor of twentieth-century Mexican art, providing the greatest of gifts to the Mexican people and to world artistic traditions.

# Mexicanidad, the Mural Movement, and Easel Painting

## Diego Rivera

The Diaz regime and its horrors were the subjects of Posada's etching tool throughout the first decade of the twentieth century, sometimes landing him in prison. But even prior to that time, Diego Rivera (1886–1957) and José Clemente Orozco (1883–1949) had become Posada's "students." Rivera, born on December 13, 1886, in Guanajuato to schoolteacher parents of radical persuasions, showed early and prodigious talents as a draftsman and painter. Only a decade after his birth, little Diego entered the night school at the Academy of Bellas Artes (San Carlos) in Mexico City to which the family moved in 1892. Rivera spent his formative years at San Carlos (through 1905). Here a rigorous course of study introduced him, in addition to technical facilities, to the astonishing forms of pre-Columbian art, to the great Mexican landscape painter José Maria Velasco, and to Santiago Rebull, a student of Ingres. Rebull had a profound influence on Rivera's figure painting. As it happened, however, the Academy of Bellas Artes was directly in front of the shop where Posada worked.

In Rivera's fond recollection, he went every day to stare at the prints hanging in the window of the shop and to watch Posada work.[12] A reproduction of Michaelangelo's *Last Judgment* alongside Posada's prints hung in the window. After a time Posada asked the young Diego if he liked the pictures and, if he did, why he liked them. Rivera answered that he liked them all. Posada asked how that was possible, leading Rivera to the Michelangelo engraving hanging next to his own illustration of a ballad. Rivera revealed that he saw the same thing in *all* of the pictures, telling Posada "Can't you see that in one as in the other, the figures seem to be moving—they move about together and they make one fear because they seem even more alive than the other people passing on the street; the figures are placed in the same manner in this engraving and also in yours." The astonished Posada replied, "Imagine, little boy, there is no one else in all the world but you and me who knows this thing!" For the

[12] See Frances Flynn Paine in *Diego Rivera*. New York: Museum of Modern Art (Exhibition Catalogue: December 23, 1931–January 27, 1932. Reprint edition, Arno Press for the Museum of Modern Art, 1972).

entire time Rivera attended the academy, he visited Posada's shop almost every day.

Posada and the teachings of the academy were not the only influences on Rivera's art. Leaving for Spain on a small grant in 1907, Rivera spent practically 14 years in Europe, all the while absorbing the panoply of artistic trends of the late impressionist and post-impressionist periods. An amazing variety of styles typified the art of Rivera at this juncture, most especially the cubist art of Braque and Picasso.[13] Events of the Russian "October Revolution" in 1917 solidified Rivera's concerns for social reform and revolutionary politics, concerns which were common to a number of European artists, including Amadeo Modigliani.

Rivera's firm dedication to creating a truly Mexican art began with the call of José Vasconcelos, the brilliant Minister of Education under President Alvaro Obregon, who was elected in 1920. After a trip to Italy in 1920 to study Byzantine and Renaissance art, Rivera returned to Mexico where, except for sojourns to the United States and the

Soviet Union, he remained the rest of his life. Rivera did not originate the mural movement (Mexican painters Jean Charlot and Roberto Montenegro had already created or were creating murals), but he invigorated it under the direction of the amazing Vasconcelos, among whose many achievements was the reduction of illiteracy in Mexico by some 30 percent and the institution of nothing less than a Mexican cultural renaissance. This visionary thinker helped create the idea of *Mexicanidad* (sometimes inaccurately labeled *indigencia*) in Rivera and in his work.[14] Vasconcelos did this with cultural subsidies and with the power of example and persuasion. Specifically, in seeking a unique Mexican art and in the attempt to persuade Rivera to take up the cause, Vasconcelos sponsored trips to various parts of Mexico with poets, writers, painters, and anthropologists. In November 1921, Rivera accompanied Vasconcelos on a trip to the Yucatan to visit the Mayan ruins and the indigenous Mayans of the day. Rivera filled notebooks and sketchbooks with drawings of the people and of the landscape. Later, after Rivera had painted his first wall (in the Anfiteatro Bolivar in the National Preparatory School) Vasconcelos sponsored yet another trip — in December 1922 to the straits of Tehuantepec in southern Mexico.[15] Rivera again filled

[13] Indeed, Rivera was a significant exponent of cubism with respect to both still life and landscape painting. This period of Rivera's life and work is well documented by Ramon Favela. See Favela, *Diego Rivera.*

[14] We use the terms interchangeably but technically only about 10 percent of citizens were pure-blooded Indians at the time.

[15] We are unaware of the present location of these sketchbooks. However, Bernard Lewin Galleries of Palm Springs, California published some of the items in *Diego Rivera: Sketch Book* and in *Diego Rivera: A Rare Retrospective Exhibition.*

many sketchbooks, entranced with the tall Tehuana women, their unique and beautiful costumes and with the lush forest landscapes. Materials in the Yucatan and Tehuantepec sketchbooks were to influence and feed Rivera's imagination—inculcating the themes of Mexican culture and folk art first seen in Posada's shop—in both mural and easel painting for the rest of his life.

As a communist, Rivera was in and out of favor with the party and would often demonstrate ambivalence to the goals of the movement. He certainly enjoyed wealth and recognition and was not above paying homage to capitalists when it was profitable. As an unabashed lover of beautiful women, he was always in trouble. (Fidelity was not a word in his lexicon). The seeming constant in his life was his relationship and marriage (twice) to the artist Frida Kahlo (1907–1954), although loyalty rather than fidelity typified the relationship. These matters, the stuff of legend and Rivera's fabulous life, have been told many times, sometimes with much dispute over facts and achievement due to Rivera's well-known penchant for hyperbole and outright myth-making.[16]

Those fascinating stories cannot be told here. Rather, consider some of the varieties of the Mexican art Rivera produced. Two early Mexican landscapes are important. A clear product of the Tehuantepec sketchbook is the work *Forest, Tehuantepec* (see FIGURE 3, page 33), a small cool-toned watercolor from 1928, clearly reflecting his earlier interest in the lush landscapes of the French painter *Le Douanier*, Henri Rousseau. The motif of this watercolor is, however, softer and less defined and static than those of Rousseau and even Rivera's earlier "pre-Mexican" essays on similar subjects.[17] In the same spirit of soft romanticism is *Yucatan* (see FIGURE 4, page 34) dated 1930–1931, almost certainly adapted from the early sketching trip to that region with Vasconcelos. This amazing charcoal and watercolor provides a bird's-eye view of a yellow river banked with foliage created in Rivera's "cartoon" style, topped with seabirds flying over the river.

These fresh tonalities were matched by increasingly simplified forms as Rivera's Mexican style emerged in beautiful and full blossom over the 1920s. The mural movement was in full swing over the entire

[16] See, for example, Rivera's friend, Bertrand Wolfe's *The Fabulous Life of Diego Rivera*, the recent biography by Patrick Marnham, *Dreaming with His Eyes Open*, and the large bibliography on Rivera contained in this latter work. Interest in Rivera has been stimulated in the deification of his talented wife Frida Kahlo in recent exhibits and in the motion picture, *Frida* in 2002.

[17] See, for example, *Edge of the Forest*, a 1918 picture illustrated in the 1931–1932 MOMA exhibition catalogue, Plate 11. Rivera was capable of painting in many styles which he did throughout his life. Echoes of the impressionism of Auguste Renoir may be found in a number of early paintings, for example.

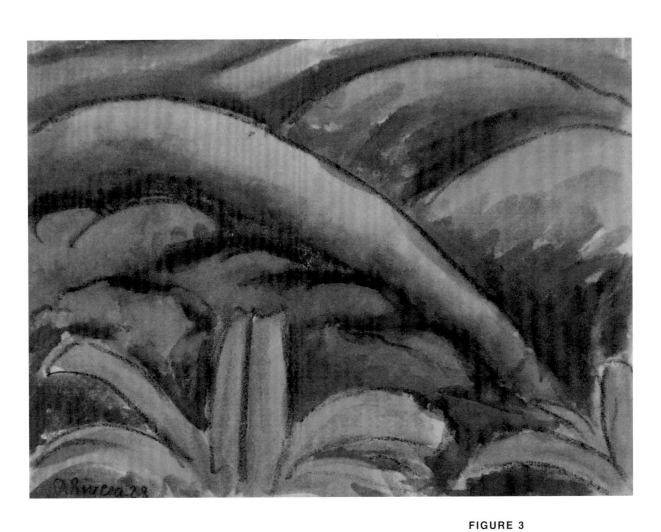

**FIGURE 3**

Diego Rivera

*Forest, Tehuantepec,* 1928

Watercolor on rice paper

5¾ x 8

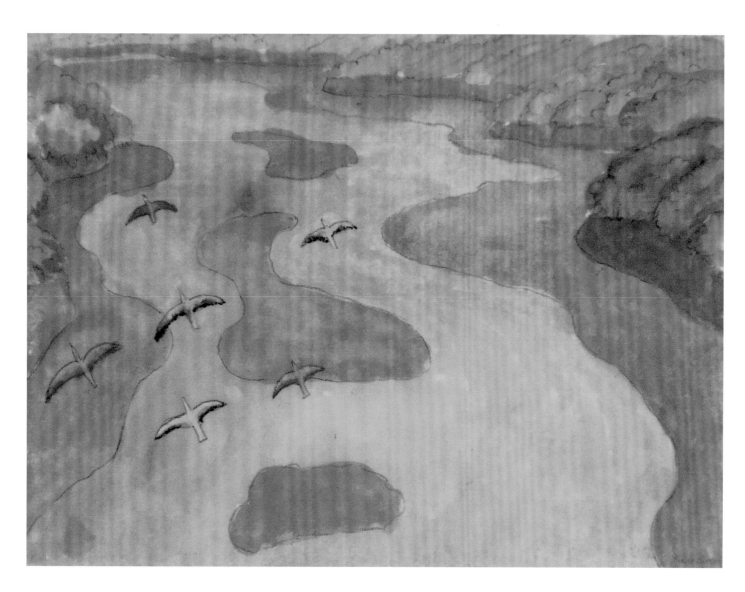

**FIGURE 4**

Diego Rivera

*Yucatan,* 1930–1931

Watercolor on rice paper

12 x 16

decade as Rivera's, Orozco's and other artist's creations began to cover walls throughout the country, especially in Mexico City. Not since the Renaissance had fresco painting reached such a degree of attention and quality, although murals had in fact been painted on the walls of Mayan temples and, later, in the convents of the Hispanic period. These artists decorated walls in the Ministry of Education, the National Preparatory School, the National Palace, and the Autonomous University of Chapingo, making fresco painting a "new" and uniquely Mexican art form. Importantly, however, easel painting and art in other forms were also being created. Reflecting styles found in his earlier forays into Mexican life and landscape, Rivera painted some of his most beautiful Mexican paintings over the great period of mural painting in the 1920s and early 1930s, including those with themes from his travels to Yucatan and Tehuantepec. (Here a number of versions in oil and watercolor of his electrifying "dancers in Tehuantepec" are representative).[18]

Another of Rivera's practices, in common with other great muralists such as Orozco and Siqueiros, was the adaptation of portions of mural paintings or the cartoons or preparatory drawings for such paintings to other media. Here we have several important examples of recycling. A good example is perhaps Rivera's most beautiful and famous lithograph entitled *Sueño,* executed in 1932. Exquisitely modeled, the lithograph is inspired by a segment of Rivera's fresco entitled *Night of the Poor* of 1928, executed on the north wall of the Courtyard of the Fiestas in the Ministry of Education in Mexico City. *Sueño* (see FIGURE 5, page 36) is representative of Rivera's mature Mexican "figure style" in the murals, realized with a tenderness and sympathy that is so often found in his major easel portraits.

Myth and the tragedies that typified pre-Hispanic, Hispanic, and revolutionary periods that engaged Posada riddle Rivera's art. These influences, together with folk art *retablos* (native votive paintings), pre-Hispanic codices, the ancient Indian pictorial and hieratic books, were all part of Rivera's artistic and personal heritage.[19]

[18] Rivera developed his first lithograph in 1930 (*Flower Market*) in a simplified cartoon style that he developed throughout the 1920s. In *Flower Market* there are themes—kneeling peasants selling flowers in sketchy poses—that are emblematic of some of Rivera's best easel work (for example, the kneeling sellers of *alcatraces*—calla lilies—and other varieties of flowers). In addition, Rivera put this style to work in illustrations for magazines and books, some of them published in North America. Two examples are *Mexico* by Alfred Goldschmidt in 1925 and, notably, *Mexico, A Study of Two Americas* by Stuart Chase in 1933, the latter presenting a socialist contrast of North America and Mexico.

[19] Rivera was one of the greatest individual collectors ever of pre-Columbian art and artifacts, surrounding himself with these items in his studios. In common with another great artist-collector of these early objects, Rufino Tamayo (1899–1991), Rivera willed his collection to the people of Mexico and established a museum to house it.

**FIGURE 5**

Diego Rivera

*Sueño (Sleep)*, 1932

Lithograph on paper

16 x 12

There are countless illustrations. Indian "mother goddesses" drawn from nature rather than with Christian orientation fill the murals and easel paintings. The enriching and healing power of blood and a circular view of time and existence, themes so common in pre-Hispanic mythologies, are a ready source of Rivera's materials as in his powerful depiction of the fecund power of the buried Zapata (National College of Agriculture at Chipango). The triumph of Mesoamerican culture over the Spanish in "rewritten history," likewise is treated in animistic fashion in the "Conquest" mural (located in Cortes's Palace in Cuernavaca), where a pre-Columbian beast with human hands stabs a Conquistador. For Rivera, the terrors and amusements of death created in all prior cultures in Mexico was a constant companion in his art and personal life. One of the last and most interesting murals is A *Dream of a Sunday Afternoon in Alameda Park* (1947–1948) in the Del Prado Hotel—a mural that was a summary of the Mexican influences on his life and art. In it, Diego, who portrays himself as a young boy, is surrounded by Frida Kahlo, Posada,

Vasconcelos, and others. But most critically, Diego is holding hands with "the Calaveras Catrina," Posada's skeletal metaphor for reform, art, life and death in all of its manifestations. There is no doubt that over a brilliant and fascinating career, Rivera created great art and came to exemplify the Mexican movement. But it is equally indisputable that myth and tragic inevitability were haunting and central ingredients in his exquisite rendering of the human condition.[20]

## José Clemente Orozco

José Clemente Orozco was, in all respects, Rivera's match in establishing an art that was "Mexican" and an agent for social change. He was, even more, a man of great contradictions and one of the greatest artists of any nationality in the twentieth century. A militant revolutionary who was not a "joiner;" a quiet, modest man whose art was filled with the most intense of human passions; a man of peace who

extolled fire and sacred violence; Orozco was all these things and much more. No artist in the twentieth century—not Edvard Munch or Georges Rouault—got as close to human suffering or to human possibility and anger over injustice as Orozco. It was said that when the philosopher Friedrich Nietzsche took to the floor to debate, it was time to call for ambulances. The same might be said of Orozco when he picked up a brush, a piece of charcoal, or an engraving tool.

Orozco was born on November 23, 1883 in Ciudad Guzmán in the coastal state of Jalisco, the son of middle-class parents of mixed Mexican race. After moves to Guadalajara and to Mexico City (in 1890), the young Orozco entered primary school attached to a teachers college. As if anticipating the experience of Rivera, Orozco's school was only a short way down the street from the shop of Vanegas Arroyo, the site of Posada and his engravings. In his *An Autobiography*, Orozco speaks of stopping four times a day to and from school to watch Posada at work and adding:

> This was the push that first set my imagination in motion and impelled me to cover paper with my earliest little figures; this was my awakening to the existence of the art of painting. I

[20] Whether or not Rivera was a "believer" is an open question. He was an on-again-off-again communist his entire life and shared the anti-clerical views of his fellow artist-revolutionaries. However, there might have been an "eleventh-hour recantation." Under some pressures at the end of his life and ill with cancer, perhaps in the spirit of lifelong pranks, he obliterated and changed the passage saying "There is no God" in his *Sunday Afternoon* (Del Prado) mural, announcing that he was returning to the Catholic faith. No one can be sure, of course, but his fear of and preoccupation with death is well known.

became one of the most faithful customers in Vanegas Arroyo's retail shop … [where] Posada's engravings were decorated by hand, and it was in watching this operation that I received my first lessons in the use of color.[21]

These influences, along with early drawing night classes at the Academy of Fine Arts of San Carlos—with a detour to the School of Agriculture in San Jacinto for three years and later returning to the Academy in 1905—were formative in Orozco's career. Early on, Orozco lost the use of his left hand in a fireworks accident but, undeterred, he embarked on a career as an artist. The spontaneity that he exhibited in his art—despite a fine classical education and training in anatomy—was derived from a number of influences, especially that of his teacher, the great Mexican landscapist, Geraldo Murillo (forever known by his Indian name, Dr. Atl).[22] Over this early period, up to his first visit to the United States in 1917, this spontaneity of form took Orozco to the hard-scrabble streets of Mexico City to depict the activities of prostitutes and the *pulque*-sodden poor.[23] Using a "quick sketch" method, Orozco's approach to these topics was totally artistic and aesthetic with no descent into sympathy or moral judgment.

In 1917, Orozco visited the United States for the first time and was greeted at the border by moralistic border police who destroyed as many as 100 of his early drawings. He spent time in San Francisco and in New York City where he was introduced to the world of high technology, including subways and skyscrapers, and to Coney Island's circus acts. Circuses have of course provided the metaphor for human life and foibles for so many artists (recall Posada and Picasso), and Orozco was no exception. The *Contorsionistas,* (see FIGURE 6, page 39) created much later in his career, and a whole series of clowns executed in an expressionist manner bear fascinating testimony to this idea.[24]

Returning to Mexico in 1921, Orozco became a leader in the mural movement then sweeping Mexico, preferring to work in

---

[21] Orozco, *An Autobiography,* 9.

[22] Dr. Atl was a formative and important character in the art of twentieth-century Mexico as a teacher and as a painter of landscapes, especially those of the volcanoes surrounding Mexico City and its environs.

[23] These drawings, prized by collectors, are reproduced in several places. The superb collection of Dr. Carrillo Gil contains a number of them (see Orozco, *Obras de Clemente Orozco en la Coleccion Carrillo Gil,* especially plates 6 through 14). Also see *Orozco,* introduction by Alma Reed, 230–242.

[24] The expressionist figures of the insane, of contorted and "dualistic" clowns and other bizarre configurations, are reminiscent of the pre-Columbian celebration of mongoloidism, dwarfism, and other genetic malformity. Those with these conditions were extolled as chosen by the gods.

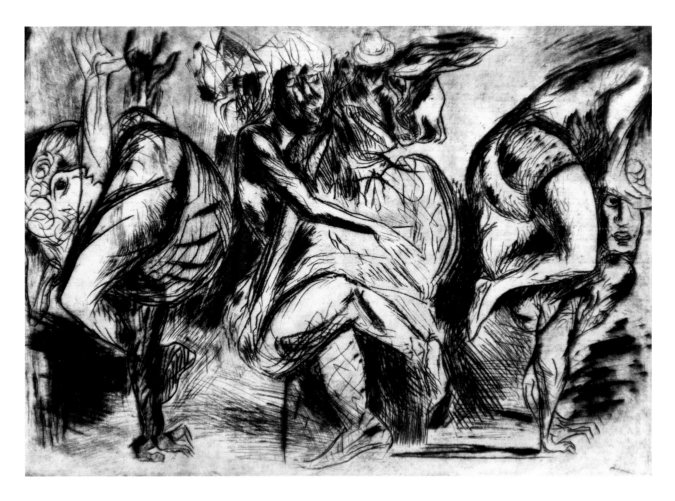

**FIGURE 6**

José Clemente Orozco

*Contorsionistas (Contortionists)*, 1944

Etching and aquatint

11$^{15}$/$_{16}$ x 17$^{1}$/$_{2}$

the true fresco manner with plaster foundation. Orozco's work encompassed revolutionary, traditional, and ironic commentary on the still-tumultuous events of the time. Only mildly anti-clerical, unlike his fellow revolutionaries, Orozco often became the target of hostility for some of his murals. In particular his depiction of a nude Virgin in the fresco of 1923 in the National Preparatory School entitled *Maternity* caused a minor sensation. This was a very fertile period: Orozco painted easel works as well as murals and began printmaking. He would create lithographs, etchings and

engravings through the mid-1940s. Among these is his *La Pulqueria* (1928), which shows "action figures" in the process of making fools of themselves, drunk with *pulque*, a drink with powers far greater than North American "white lightning."[25] This powerful caricature is only an observation on the life of poor *indios* (*mestizos* and all other Mexicans drank also), not an indictment of such behavior. And Orozco made a practice of "recycling" some of his best images from murals (or preparatory drawings for murals) to works on paper. *La Chata* (*Head of Woman*, 1935), for example, is a dry-point replica of a figure from *Catharsis* (1934), his mural in the Palace of Fine Arts in Mexico City.

It is difficult to appreciate Orozco's aesthetic without reference to his central belief, pre-Columbian to the core, that a kind of dualism was attached to human life within which, as the ancient ones believed, time was circular rather than linear. In this aesthetic, humans were attracted to good and to high aspirations of justice and achievement but were, simultaneously, filled with primal impulses. The dichotomy between good and evil, day and night, summer and winter, was played out in human life. There was a worm in every apple in this never-ending cycle. Death is the worm but *also* the seed. Technology lifted men from burden, for example, but it also dehumanized them. In Orozco's case, hope was always balanced with pathos and despair, pity with terror, beauty with disorder and distortion. Orozco's figures contained "bland" faces or none at all.

Throughout Orozco's life, the Revolutionary period, especially from 1910 through 1921, was a backdrop of an eternal and endlessly repetitive play from which to view the entire history of man on earth. Orozco's art might be viewed as one through which this aesthetic was placed in representations of particular myths, actual events, and human rituals and activities. Ordinary life animated Orozco's philosophical beliefs and art theory or arcane wisdom was abhorrent to him. Two murals, painted on his second visit to the United States (1927–1934)—*Prometheus* at Pomona College and *American Civilization* at Dartmouth College—reveal this grand aesthetic as do his great mural works painted in Mexico throughout his life. In some sense, however, Orozco's exploration of these themes is even more direct (and disturbing) in his etching and easel works over the 1930s and 1940s. A number of etchings and engravings exist in which human nature is revealed to be fundamentally duplicitous. His capacity to depict, in

[25] The *pulqueria* was a popular repository of "bar art"— figures drawn on walls inside and out as a popular art form. Orozco's lithograph is probably related to a more formal depiction (in particular, to an oil painting in the Carillo Gil collection).

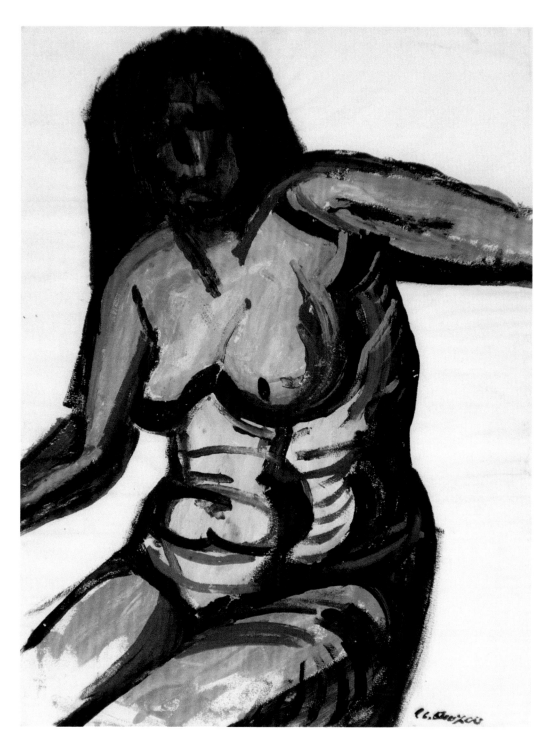

**FIGURE 7**

José Clemente Orozco

*Female Nude*, c. 1945–1946

Gouache on paper

22 x 16½

expressionist manner, both terror and beauty is revealed in works such as his late *Female Nude* (see FIGURE 7, page 41), painted in gouache circa 1946. After the initial shock of the painting wears off, a tender as well as a terrifying revelation greets the viewer. In these, as in so many of his images, Orozco lays out a view of humanity that is shocking, beautiful, and unforgettable.

---

## David Alfaro Siqueiros

David Alfaro Siqueiros (1896–1974), the third and youngest of the great triumvirate of early twentieth-century Mexican artists, developed a style that was in sharp contrast to both Rivera and Orozco. He was, at base, an artist of movement, experimentation and abstraction. Whereas Orozco was a "quiet revolutionary," Rivera a fervent if opportunistic one, Siqueiros was a militant "bomb-throwing" communist of a Stalinist persuasion. He was in jail for revolutionary activities seven times, the first at age thirteen for throwing stones at his art professors and the last between 1961 and 1964 for subversive political activity against the Mexican government. Moreover, it is most likely that he participated materially in the 1940 plot to kill and eventually murder Leon Trotsky, the left-wing communist the-orist who fled to Mexico (as a guest of Rivera and Frida Kahlo) to escape right-wing purges in the then-Soviet Union.

Born in Chihuahua in 1896, Siqueiros studied art at the art academy of San Carlos and joined the army in 1913. After visiting Europe between 1919 and 1921, when he met Rivera, and a post as a military attaché at the Mexican legation in Paris, he returned to Mexico to paint murals and to fuel the socialist movement. (Such government posts and assignments were often only subsidies to artists and carried few or no duties.) Siqueiros was central to the unionization of artists (painters and writers) and with Rivera published a communist newspaper, *El Machete* (the Mexican equivalent of the *Hammer and Sickle*) to sell communism to the Mexican masses. In the mid-1920s, Siqueiros organized miners in Jalisco and did more publishing, this time a virulently anti-clerical paper called *El 130*. In 1924, he painted a mural in the National Preparatory School in Mexico City mocking God, the Church, and the aristocracy. Church-going students defaced the mural. Siqueiros was always a troublemaker and was always in trouble, but more than all this, perhaps, he was an artist of large and experimental gifts.

Siqueiros's style in both mural and easel painting is distinct and instantly identifiable. Sinuous, curving lines of figures with exquisite and accurate draftsmanship typified his style, which is best described as one of motion. In addition, during his visits to the United States (at least the ones from

**FIGURE 8**

David Alfaro Siqueiros

*Jesusito Sera un Santo (Little Jesus will be a Saint)*, c. 1960

Color lithograph on paper

21 x 15½

**FIGURE 9**

David Alfaro Siqueiros

*Nostalgia for Liberty*, 1966

Oil on board

12½ x 10

which he was not deported), he brought experimental methods such as the use of spray guns to bear on artistic creativity. Jackson Pollock was one of his students during a 1936 visit, a contact that had fairly obvious results on the development of abstract expressionism in the following decade in the use of new techniques and materials.

While Siqueiros was often not on friendly terms with Rivera and Orozco, his thematic material, based on a combination of revolutionary fervor and pre-Columbian, anti-colonial, anti-clerical subject matter, was in concert with that of his illustrious artistic contemporaries. A central figure in some of his greatest mural paintings was the pre-Columbian figure of Cuauhtémoc, the Aztec prince that Siqueiros personifies as the defender of Mexican civilization against Cortes. In Siqueiros's version of the tale (mural in the Palace of Fine Arts, Mexico City), Cuauhtémoc recognizes that Cortes is *not* the mythological personification of the god Quetzalcoatl. The Indian prince's torture and mythological return as a morally superior force is the stuff of myth-making and of one of Siqueiros's greatest mural series.

The same style that typified the murals was also used in easel and graphic works. *Jesusito Sera un Santo* (see FIGURE 8, page 43), a color lithograph inspired by an easel work, is one of true *Mexicanidad*, wherein little "Jesusito"—a poverty-stricken young boy—achieves the status of sainthood. The materials suggested in this lithograph may be seen in the acrylic-on-board (or mixed media) painting entitled *Nostalgia for Liberty* (see FIGURE 9, page 44). The latter is a good example of Siqueiros's free brushstroke. It is perhaps best described as an "abstract landscape," a style that he adopted with increasing frequency in his later works. Both of these images were painted between 1961 and 1964 while Siqueiros was incarcerated (*Carcel Preventiva*). Many of the large number of small paintings over this period carry the prefix C. P. by his name to indicate the location of their execution (see FIGURE 9, page 44). Interestingly, even when Siqueiros was imprisoned, he was allowed freedom to paint although the size of his supports were limited.[26]

Post-revolutionary Mexican politics were filled with treachery and deceit well into the second half of the twentieth century, but real progress was being made. The constant battle between democratic and socialistic forces against aristocratic and fascist elements in Mexican society was played

[26] In 1965, the Galeria Misrachi published a book, *Siqueiros*, containing an essay on this period in the artist's life. These small pictures, profound in their subject matter, all appear to demonstrate a "yearning for liberty" as their theme.

out over a period of great literary and artistic changes. The period was distinctly anti-North American amongst the artists (Kahlo famously called the U. S. "Gringolandia"). In 1938, the Mexican oil companies were nationalized and, in common with the North American philosophical milieu of the 1930s, communism was popular in the universities and among intellectuals and artists. Mexican and U. S. artists exemplified all of these causes, but there were fundamental differences between developing conditions in the United States and in Mexico. Communists and Marxists everywhere were caught in a real dilemma. The emergence of fascism in Italy, Spain, and Germany had to be resisted. The United States, England and the other Allied Powers were the only nations capable of defeating this great enemy. This fact, plus the excesses of Stalinism and strong economic recovery, reduced the attraction of communism in many areas of the world, including the United States.

U.S. artists invented abstract expressionism in the 1940s partly under the influence of Mexican artist-teachers who visited North America. This development greatly reduced artistic expression for social change that played a strong role in art during the 1930s.[27] In Mexico, however, economic and political institutions were not as adaptable and the tradition of revolution continued unabated in mural production, in great easel works and in the media that helped undergird the entire movement — graphics as polemic and graphics as art. In 1940, Rivera, Orozco and Siqueiros still had years to live and work. But, in addition to the continuation of their great work, the 1940s in Mexico saw the splendid invigoration and organization of the graphics art form to express myth, tragedy, and reform as communist and anti-fascist ideals.

[27] It is a remarkable fact that the cross-fertilization of Mexican and North American art was active, vigorous and, for the most part, completely unfettered. Americans—ash-can, modernist, and regionalist artists—learned much from the "new" Mexican art form of mural making with the WPA and elsewhere. Likewise, American artists and intellectuals fueled Mexican movements in Mexico. The American Pablo, *nee* Paul, O'Higgins, and silver artist William Spratling come to mind as two of a small army of U. S. artists who went to Mexico to join the movement. The great photographer Edward Weston, who brought Tina Modotti to Mexico, worked in the movement, as did a number of Americans from the South, including Spratling and Southern U. S. artist Maltby Sykes (see, for example, Littleton, *The Color of Silver*. A full chronicle of these artistic interconnections remains to be written.

# Political Activism and Mexicanidad

The remarkable tradition created by Posada and developed so brilliantly by Rivera, Orozco, and Siqueiros in mural and easel painting was, to a certain extent, developed by these same artists in graphics of the 1920s and 1930s. We have seen examples of this work that was mainly, but not exclusively, derived from the murals of the triumvirate. Just as the United States created the Works Progress Administration (WPA) and all manner of subsidies to various types of workers, including artists, during the Depression of the 1930s, workers' collectives of all types were formed under Lázaro Cárdenas' socialist regime (1934–1940) in Mexico. In 1933, the artists formed the *Lega de Esritores y Artistas Revolucionarios* (LEAR) to unite artistic endeavor, to act collectively for the democratic rights of the people, and to promote all manner of socialist aims. While this organization failed due to internal problems, another organization with the same aims followed in 1937, called the *Taller de Grafica Popular*, to continue the work of Posada in giving a voice to "the people." Many great artists banned together under this banner, including Siqueiros, Ignacio Aguirre, Raul Anguiano, Louis Arenal, Angel Bracho, Jesus Escobedo, Leopoldo Mendez, Pablo O'Higgins, and Alfredo Zalce.[28]

The backdrop of this organization must be kept firmly in mind. Church property had been expropriated in the late 1920s, land "reforms" created smaller holdings out of feudal-aristocratic estates, the railroads were "given" to the workers, and the oil industry was nationalized. Fascism everywhere was resisted by democracies or would-be democracies—Mexico even sent aid to the Spanish resistance in the 1930s—and communism seemed to be the answer. Against this national and international scenery, members of the Taller went to work. Posada-like caricatures of oil barons, aristocratic folks, ivory-tower academics, Yankee "imperialists," and the horrors of poverty and unemployment were all popular images. Importantly, the Mexican situation in the 1930s and 1940s, and well into the 1960s, was seen as an extension of the great revolutions of the nineteenth and early twentieth centuries. Zapata and Pancho Villa and other revolutionary figures

---

[28] By 1957, twenty-five artists were members of the Taller with about twenty additional "guest" members using facilities (see Haab, *Mexican Graphic Art*, 7.

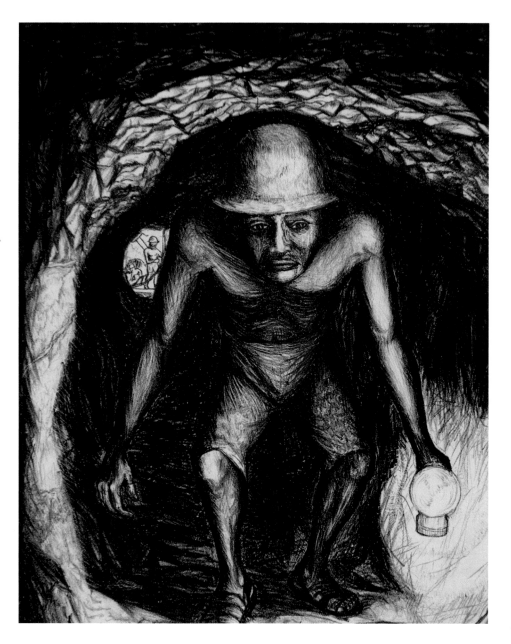

**FIGURE 10**

Francisco Mora

*Miner*, 1947

Lithograph on paper

14¾ x 12

"false" and true, together with heroes of various phases of the Mexican revolution (Juarez, Morelos, Obregon, and so on) were also the subjects of the *Taller* artists. Output was massive in quantity. The selection contained in this exhibit is small but illustrative. While Orozco was not a member of the *Taller*, his lithographic essay on unemployment, *Out of Work,* is typical of the Depression-inspired art of the group. The compositional qualities of this print display the kind of genius that Orozco spent on his larger works. Graphics by Leopoldo Mendez, Pablo O'Higgins and Alfredo Zalce very clearly express the revolutionary fervor of the *Taller.*

Revolutionaries on both sides of the gun were frequent topics. Zalce depicted the revolutionary as an arbiter of life and death, ordering the murder of dictators, aristocrats, and other persecutors of the poor. O'Higgins satirized the "rights of the ruling classes" with a merciless *calaveras* of a professor in academic robes dancing with a

woman of high class, bedecked in jewels. In such works, tragedy, politics, and pre-Columbian preoccupations with death come together in comic satire! The renditions of Mendez, perhaps the leading figure in the *Taller* movement, show that the price of revolutionary sacrifices for the "masses" was death at the hands of the army and "strongmen." *Calaveras* posters and broadsides were produced by the *Taller* artists to educate the illiterate masses to revolt and communism. Posada's inventions were again used to sell ideas. Images of property and income redistributions, the evils of inflation, unemployment and the black market were attacks on the conservative elements in Mexican society. The plight of the common laborer was an especially interesting subject. *Miner* (see FIGURE 10, page 48) by Francisco Mora, who made several lithographic studies of working conditions in that industry in 1947, is an excellent example of art as polemic—in this case a drawing of superb perspective and imagination.

The many fine artists of the *Taller* were not only involved in polemic—many of them had artistic careers outside the graphics workshop. Zalce produced a number of works in the 1940s with subject matter that was purely artistic rather than political in nature. In 1945, he toured the tropical states of Yucatan, Campeche, and Quintana Roo, creating a whole set of prints (*Estampas de Yucatan*) and a number of important easel works. One of them entitled *Paisaje de Yucatan* (see FIGURE 11, page 50) is a romantic rendering in chalky gouache of the Yucatan landscape. This imagery is also replicated in his prints of the period, revealing a sensitive approach to both figure and landscape painting. The romanticism of *Mexicanidad* continued for the rest of the twentieth century in the works of many artists. Art in service of social protest also continued for a number of decades, although the political climate was less socialistic in the later 1940s. By 1950, Mexico had become more of a "mixed economy" in search of economic growth and social and political stability.

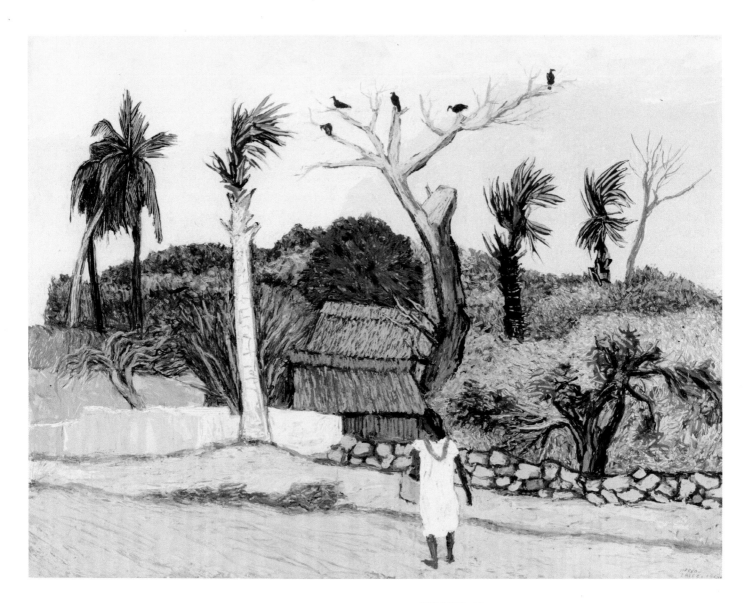

**FIGURE 11**

Alfredo Zalce

*Paisaje de Yucatan*, 1946

Gouache on paper

19 x 25½

# Artistic Individualism: Reactions to Mexicanidad and Politics

*T*he post-war world of Mexican art did not, generally, follow in the artistic *styles* of Rivera, Orozco, and Siqueiros or the revolutionary activities of the artists of the *Taller de Grafica Popular,* although there are a few exceptions. As Mexican socialism gave way to freer markets and more open trade relations with the rest of the world, most especially the United States, new windows opened in artistic endeavor. International art movements had to have a distinct influence on Mexican artists: Artistic refugees from Europe fled to Mexico, and Mexican artists traveled to Europe and the United States. While the Mexican artists of the first half of the twentieth century were exogenously influenced to varying extents, the primary emphasis in their work was on indigenous problems, myths, society, and political protest. Later reactions to this earlier art did not (could not?) abandon past influences and artistic predilections, but a central reaction against a "collectivist" purpose in the artistic community and a quest for artistic independence and individuality may be identified.

This reaction was not abrupt and cannot be identified as a discrete change. It had been ongoing throughout much of the century, contemporaneous with the mural and protest movements and the styles and approaches of Rivera, Siqueiros, and Orozco. Much of the reaction was supported by European movements and artists (especially Picasso and the European surrealists such as Andre Breton), but the vast majority of Mexican artists working from 1950 to the present would not escape the impact of Mexico's tradition of tragedy, myth, and romantic statements on the human condition. The important "isms" of world artistic creativity became a central component of Mexican art over this period, but the uniqueness of a Mexican tradition—one grounded in pre-Columbian and Hispanic mythological and religious concerns—remains inherent in the art to this day.

## Mexican Surrealism

The beauty and tragedy of Mexico, its history, people, and landscape is a ripe environ-

ment for surrealism. (Breton suggested that the whole country is a surrealists' paradise). Without question, Mexico produced and continues to produce a number of major artists whose primary subject matter combines myth, dreams, and indigenous influences. Two of these artists spanning the twentieth century are represented in this exhibit—Rufino Tamayo (1899–1991) and the British émigré Leonora Carrington (1917–).

Next only to Rivera (and more lately to his wife Frida Kahlo), Rufino Tamayo, an artist with a truly international reputation, became the standard-bearer of Mexican art. His work evolved from modernist forms of *indigencia* (or *Mexicanidad)* in the 1920s and 1930s into a unique blend of European currents such as surrealism and abstraction. His mode incorporates the combined spirit of contemporary Mexico and its aspirations to pre-Columbian art with global influences. Tamayo's massive achievement in quality and output over a very long productive life, moreover, contains a personal iconography that is unique and extremely beautiful.

Born in Oaxaca in 1899, an orphaned Tamayo moved to Mexico City in 1911 to live with his extended family that operated a market fruit stand. Tamayo worked there to earn his keep and never forgot the luscious and sensuous colors of the fruit, especially

the watermelons. That sense of color was to become a dominant aspect of his art. He studied at the Academy of Fine Arts in Mexico City between 1917 and 1921, when he took up an appointment as chief draftsman in the Ethnographic Department of the National Museum of Anthropology in Mexico City. No artist of his time, save possibly Rivera, received more of an international education in art. Like the famous trio, Tamayo painted murals including a powerful one in the National Museum of Anthropology called *Struggle between Day and Night.* (Several were also painted in the United States). But early on he completely rejected the idea that art should be political polemic and left Mexico for over three decades, living in New York for 20 years and Paris for 12.

International influences, especially those of Picasso, DuBuffet, and in the 1940s, Willem DeKooning, contributed greatly to his mature and unique style. His art developed from a stylized presentation of forms, to an obvious concern with primitive representations and, especially after exposure to Picasso, the development of a personal iconography. His personal language reflects an interest in developing sensations and forms in space. As Tamayo's art matured, color, form and texture were combined to express beauty as energy, not as simply proportion or traditional perspective. Thus Tamayo is entirely unique and difficult to group with a "school" or philosophical movement, although there are clearly surrealist, expressionist, abstract, geometric

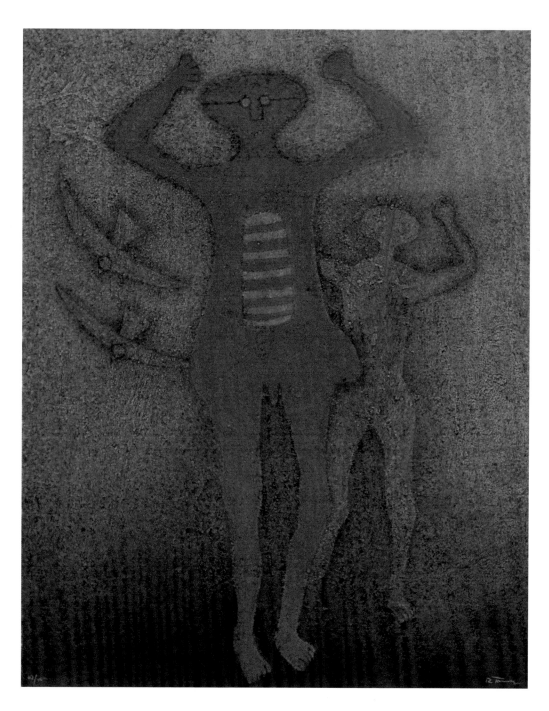

**FIGURE 12**

Rufino Tamayo

*Personajes con Pajáros (People with Birds)*, 1988

Mixografia on handmade paper

43 x 35

**FIGURE 13**

Rufino Tamayo

*Sandias (Watermelons)*, c. 1970

Mixografia on handmade paper

29¾ x 22⅝

(Cezannesque), metaphysical, and religious elements in his art to mention only a few. Despite the fact that Tamayo's style and reception was international, his art was always identifiably Mexican.[29]

More than anyone, perhaps, the great Mexican poet, writer, art historian, and critic, Octavio Paz, understood and appreciated Tamayo's art. In his essay on Tamayo for the latter's retrospective at the Solomon

Guggenheim Museum in 1979, Nobel laureate Paz wrote:

> This artist, sometimes so light-hearted and tender, can be cruel: humor is central to his work. But the roots of his cruelty lie neither in irony nor in the logic of a system, but in satire and a sense of the grotesque. A love of monsters, phenomena and freaks is part of both the Indian and the Spanish heritage. Pre-Columbian art is filled with deformed beings, and the same is true of the great age of Spanish painting.... Tamayo's painting is rich in monstrous, sordid or farcical personages—the glutton, the laughing-man, the society lady, the maniac, the idiot and other absurdities.[30]

Paz goes on to speak of Tamayo's depictions as those of the physical, not the metaphysical, world and of his fascination with the dualisms of life and death. Here, for example, the bone achieves cosmic significance: "Dog's bones, a bone moon, bone bread, man's bones, bone landscape: a charnel planet."[31] It is, however, not the Mexican's fascination with death or with pre-Columbian sculpture that explains Tamayo's art. These confrontations, Mexican in orientation, must be translated through the artist's particular and unique modern aesthetic.[32] However, the fact is that Tamayo

[29] Like Rivera, Tamayo was a great collector of pre-Columbian art and artifacts, a collection that he established as a museum gift to the Mexican people.

[30] Guggenheim Foundation, Octavio Paz, "An Art of Transfigurations" in *Rufino Tamayo: Myth and Magic*, 15.

[31] *Ibid*. Tamayo himself noted these influences when he said that "there is the mystery which exists in Mexican art, and not only in art but in the whole Mexican ambience, which is tragic and full of sorrow... Simply the idea of death in my country is very particular. The Mexicans are not supposed to care about death. That's a tradition from centuries back. Death is to be made fun of—it's a kind of tragicomedy. It's full of ironic overtones. When someone dies, the family sends little candy skulls to everybody and everybody eats them..." (Tamayo quoted in Associated American Artists, *Rufino Tamayo*, 4.

[32] One, for example, does not have to be Mexican in blood to be Mexican in culture and, in this sense, art is not necessarily "Mexican" or "Gothic," but is completely international in nature. Paz brilliantly explains this point when he notes that "In art there is no such thing as inheritance: there are discoveries, conquests, affinities, abductions—re-creations that are really creations. Tamayo is no exception. The modern aesthetic opened his eyes and made him see the modernity of pre-Hispanic sculpture. Then, with the violence and simplicity of every creator, he took possession of these forms and transformed them. Using them as a starting point he painted new and original forms" (Paz, op. cit., 20). Also see Paz, *Essays on Mexican Art*.

*was* Mexican, steeped in Mexican history and culture and was, certainly in a probabilistic sense, more likely in the extreme to produce an art that though international and personal in style, can be labeled "Mexican." And that he did.

Tamayo's easel works in oil and works on paper were brilliant in color and execution over a long and productive life. In the 1970s, however, together with the printer Luis Remba, Tamayo began to make innovations in the printing process at the Mixografia print studio in Mexico City. By 1977, they developed a process whereby the artist creates works with textures, sometimes collaged with actual materials, on wax, after which a copper mould is created to produce "reliefs" in paper, also called *mixografia*. (In the process, wet handmade paper is highly pressured into the mould to produce a textured print). *Cabeza en Negro* is one of the first of these images, evoking pre-Columbian sculpture but in an extremely contemporary context of stylized geometry. Textures and contours characterize the easel-like format of the work, especially the rectangular base of the picture.

In *Personajes con Pajáros* (see FIGURE 12, page 53), created in 1988, Tamayo again recalls pre-Columbian myth wherein the birds are the messengers of the gods to man and man to the gods. Note, most particular-

ly, the almost exclusive use of orange and red shades in the picture, a colorist convention that marks Tamayo's entire *oeuvre.* Finally, geometry, color and subject matter come together in Tamayo's study of watermelons — *Sandias* (see FIGURE 13, page 54) — one of a number of works devoted to this subject. Again, color and color variations are integral rather than incidental to the picture. Themes of mythological dualism and pre-Columbian sculpture also converge in his work. The frailty and circular continuity of life, as Paz suggests, are depicted in the seemingly simplest of motifs, such as the counterposition of pre-Columbian figures of dogs barking (see FIGURE 1, page 23) at the moon such as Tamayo's *Perro Aullando a la Luna* (see FIGURE 14, page 57).

The surrealist landscape in twentieth-century Mexican art was also forcefully exemplified by a number of other important artists, most of them women, including Maria Izquierdo, Remedios Varo, Frida Kahlo, and Leonora Carrington. Carrington, an English student of European (French) surrealism, was born in Lancashire, England in 1917, becoming introduced to and escaping to France with Max Ernst, her companion and one of the originators of the movement. The European surrealists disbanded in 1940 in the midst of war and Carrington, suffering a mental breakdown, married a Mexican diplomat named Renato Leduc. In 1942, the pair spent a year in New York in a circle of surrealist "refugees" including Andre Breton, after which they left for

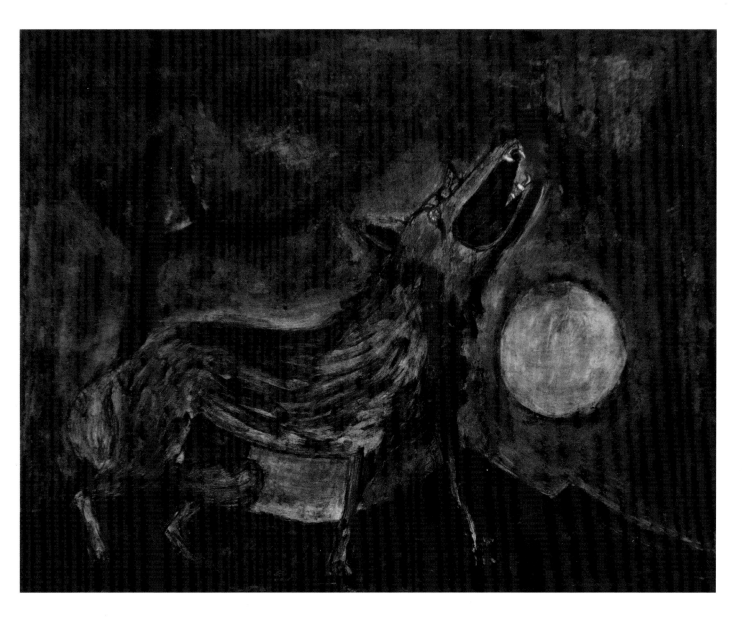

**FIGURE 14**

Rufino Tamayo

*Perro Aullando a la Luna*

*(Dog Howling at the Moon)*, c. 1950

Color lithograph on paper

17¾ x 22

Mexico. After an amicable divorce, a subsequent marriage, and integration with a host of surrealists living in Mexico including Varo and Kahlo, Carrington continued her career as an author and as a painter.

As an emigre spending most of her life in Mexico, Carrington used the myths of her childhood and European experience to develop her particular language in art. While Mexican influences are not so overt in her

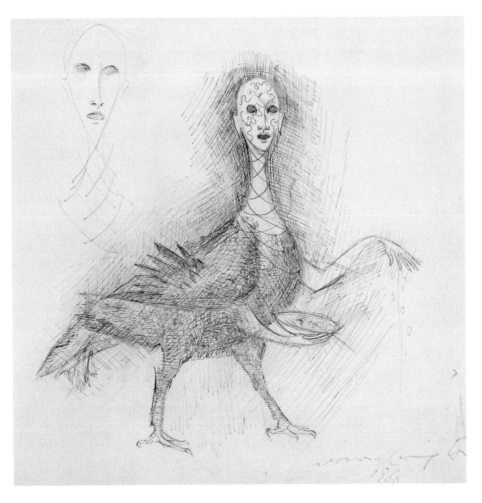

**FIGURE 15**

Leonora Carrington

*The Bird Feeder*, 1960

Ink drawing

8¾ x 10

work, concepts of Jungian psychology, Tibetan Buddhism, Celtic myth and cabalistic literature are. The dualistic world of gnosticism, wherein female power contrasts with attempted male domination, is often found in her paintings and drawings. Works such as *Tuesday*, a lithograph from 1987 (inspired from an oil painting of 1946), show a procession of symbols and trials through which humans and animals progress. Alternative realms of reality are suggested.

Birds and eggs appear to be of significance in her work. (An egg is an alchemical symbol of creation.) An ink drawing from 1960 entitled the *Bird Feeder* (see FIGURE 15) shows the circularity of time and creation as represented by a bird with a "human" head that throws feed into space. A disembodied human head observes from the upper left side of the bird–human. Thus, human beings appear both as actors and as observers in posing never-ending surrealist questions concerning existence and creation.

While Carrington's themes are sparing in their use of direct reference to pre-Columbian myths, there are important exceptions. In 1963, she was commissioned

to paint a mural in the new National Museum of Anthropology in Mexico City. That mural, entitled *El Mundo Mágico de los Mayas*, now in the regional museum at Tuxtla, integrates pre-Hispanic and Hispanic images with her unique iconography.[33] These and so many other mysterious and startling images created by Carrington have made her a leading surrealist in Mexico and around the world.

---

## La Ruptura: José Luis Cuevas

José Luis Cuevas (1933–) is one of only a handful of internationally known and acknowledged Mexican masters of drawing, with his work illustrated in a number of drawing textbooks.[34] After only one academic course, the young and rebellious Cuevas set out to overturn the directions of Mexican art; that is, to set Mexican art on a path away from social and political protest, which frequently took the form of didactic murals depicting the tortuous trail of Mexican history. Purposefully, in essays, magazines, and newspapers, Cuevas founded a movement called *La Ruptura* in order to "internationalize" Mexican art.

After an initial exhibition while in his teens, Cuevas was invited to exhibit in the United States at the Pan American Union in Washington, D.C. in 1954. He exhibited in New York, Paris, Venice, and Rome and won many of the most prestigious awards in Latin America and Europe. He also gained the respect of such figures as Picasso, who purchased several of his drawings. Cuevas has a unique style which makes his work readily identifiable. An absolute master of the line and "gesture" drawing, Cuevas nonetheless appears to create moods and depictions very close to the expressionist master Orozco. Cuevas was, like Orozco, attracted to the desperate life of people on the streets. Beggars, prostitutes, the downtrodden, depravity, and death are the subjects of these drawings. Love of the grotesque led Cuevas, in many of his drawings of the later 1950s, to create "monsters"—misshapen humans revealing an inner humanity that is both touching and frightening. These unsettling themes are repeated throughout the canon of Cuevas's work. A master printmaker, Cuevas transferred his great talent to that medium in the 1960s, creating a body of work that included similar subjects (such as his much-acclaimed *Crime Suite* in 1968). The series was printed in Barcelona, a frequent residence for the artist. Miscreants of all kinds are captured in unforgettable gestures and poses.

---

[33] See Chadwick, *Leonora Carrington*.

[34] See, for example, Claudia Betti and Teel Sale, *Drawing: A Contemporary Approach*, 3rd ed. (New York: Harcourt Brace College Publishers, 1991), 94.

**FIGURE 16**

José Luis Cuevas

*El Bruno and His Mother,* 1976

Ink and watercolor on paper

11¼ x 18

An intense passion for history and literature is revealed in many of his works that, like Picasso's later drawings, parody or illustrate the scenes of real or imagined history or of great artists or artistic subjects of the past. Above all, the Mexican penchant for magic and mystery, suggested in the great number of fortune-tellers all over that country, is present in his work. *El Bruno and his Mother,* (see FIGURE 16) a drawing to which watercolor is incidental, is a fine representation of his style. Cuevas is able to regulate the density and direction of his line to reveal the most intense inner feelings of figures depicted. With few exceptions—Picasso or

Egon Schiele come to mind—the ability to create mood has rarely been captured with such economy.[35] The key to interpreting Cuevas, according to the late José Gómez-Sicre, one of his earliest champions, is "the aboriginal art of his own people: the archaic, hieratic strength of pre-Columbian sculpture, with its unshakable solemnity and unerring interplay of volumes.

## An Art of Geometric Abstraction

The *Ruptura* movement was most certainly not the only artistic school rejecting the polemical traditions of Rivera and Siqueiros. It is noteworthy, however, that a school of abstract art developed in Mexico as well. Along with artists such the late Gunther Gerzso (1915–2000), Carlos Merida (1891–1984) began, early in the twentieth century, to apply abstract geometric principles to the traditional art of Mexico. Merida was born in Guatemala City, Guatemala, and after a youthful interest in music, took up painting. A trip to Europe introduced him to the work of Picasso and Rivera, and he studied with Kees Van Dongen and Amadeo Modigliani. He returned to Guatemala and then moved permanently to Mexico in 1919. Under the influence of his European experience Merida began experimenting with structured abstraction combining bright colors with "floating" figures, some in traditional Mexican garb and others suggesting pre-Columbian figures. As Merida's art became more abstract and geometric, the representational qualities of his easel works and watercolors declined.

Merida's mature style, while essentially non-representational in quality, continued to integrate pre-Columbian motifs into linear geometry. Of enormous influence on his art was the *Popul Vu*, the sacred book of the Mayans. In works such as *Construction in Red* (see FIGURE 17, page 63), the movement contained in *Popul Vu* is suggested. It also appears in his desire to "integrate" the arts: his mural designs for the multifamily apartments in Mexico City are direct abstractionist translations from that famous codex.[36] Further, we find this kind of unique figuration in his extension of design to sculpture, although he made few excursions into this medium. At base, Merida was able to develop an art that, while European and modernist in form, contained a potent dose of

[35] Cuevas, ever the rebel showman, is not only a brilliant draftsman but is a speedy one as well. On a bet, Cuevas filled a sample book containing various types of papers with 105 drawings of him and a model. He completed this dazzling display of technique in a 24-hour period on April 27 and 29, 1981. See *José Luis Cuevas: Self-Portrait with Model*, introduction by José Gómez-Sicre, New York: Rizzoli, 1983.

[36] The apartments (*Multifamiliar Juárez*) in Mexico City were destroyed in the 1985 earthquake. But a monumental restoration of portions of the murals was made in 1988. See Diaz de Cossio (ed.), *Carlos Mérida.*

myth and magic, so characteristic of Mexican art in the twentieth century. Merida was joined, both in an abstract approach to myth and in an integration of indigenous culture with modernism by a number of artists and sculptors (for example Luis Ortiz Monasterio (1906–1990).

## Romanticism

Some Mexican artists rejected *both* the politics and polemics of Rivera, Siqueiros, and the members of the *Taller* as well as the concept of *indigencia* and *Mexicanidad.* Others rejected politics but espoused a beautiful romanticism based on indigenous themes. These artists integrated the romantic and neo-romantic styles of Rivera and the Europeans while simultaneously producing unique forms of that genre.

One of the earliest and most successful of these artists was Jesus Guerrero-Galvan (1910–1972). Galvan's style crystallized in the 1930s in poetic figure drawings, especially of children. These weightless, elegant, dream-like paintings and drawings present figures as if encased in a "womb" of color and atmosphere. Here are figures that draw on academic or classical principles combined with the "weight" of Picasso's neoclassical (or Aztec) figurations of arms and legs. His

pencil drawings of the mid-1930s, the basis of oil paintings created in that decade, perfectly demonstrate this unique combination of styles. Galvan's watercolor entitled *Girl Enchanted by a Beam of Light* (FIGURE 18, page 64) also adds an element of surrealism to what is basically a traditional figure drawing. Galvan's style became more brittle and angular later in his life, but the mystical and mysterious orientation continued throughout his long and successful career.

Francisco Corzas (1936–1983), in a relatively short life, also displayed a brilliant and unique kind of neo-romanticism. Born in Mexico City, but clearly influenced by Spanish painters, Corzas, a master draftsman, brilliantly translated the style of Valasquez and other Spanish icons into yet another unique kind of romantic neoclassicism. As is so often the case, the artist's drawings often provide insight into his or her style than elaborate finished paintings. Such, perhaps, is the case of Corzas, who used historical and biblical references to portray stories or scenes of the human condition. In numerous ink wash drawings such as the untitled one (see FIGURE 19, page 65) in chiaroscuro, mysterious figures appear to act out a kind of drama, accentuated by the overt *pentimenti*—leavings of earlier figurations in a drawing.

Yet another artist of international stature fills the space of Mexican romanticism. Francisco Zuñiga (1912–1998), Mexico's greatest sculptor of the century, was also a superb draftsman and lithographer. Born in San José, Costa Rica, Zuñiga

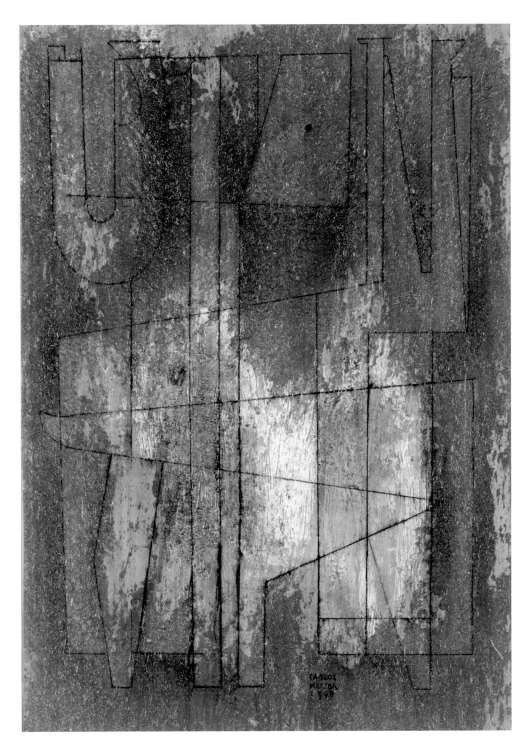

**FIGURE 17**

Carlos Merida

*Construction in Red*, 1968

Oil on board

14¾ x 10½

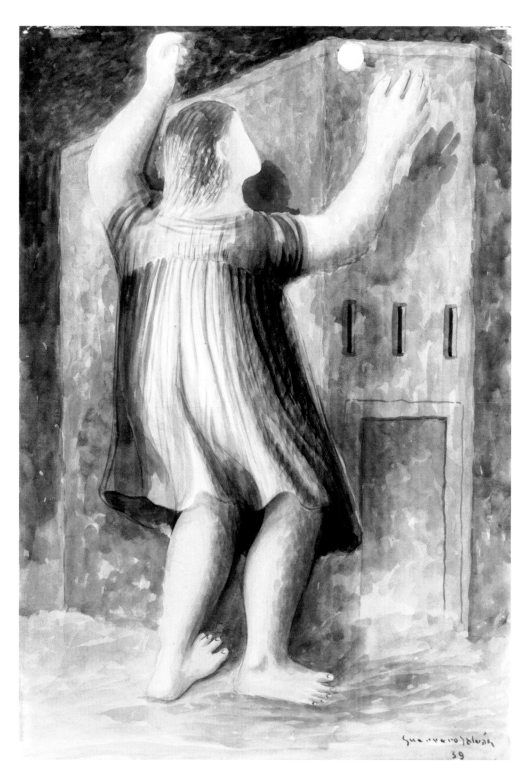

**FIGURE 18**

Jesus Guerrero-Galvan

*Girl Enchanted by Beam of Light*, 1939

Watercolor on paper

18 x 12¾

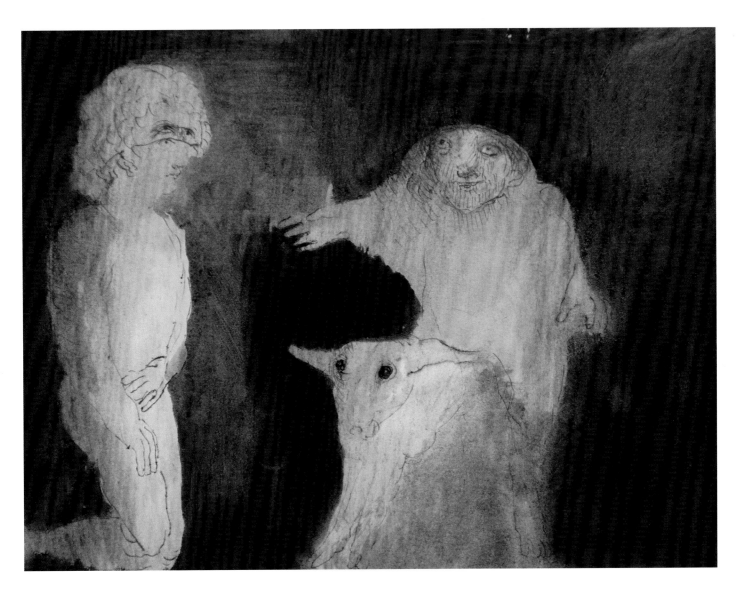

**FIGURE 19**

Francisco Corzas

Untitled, 1963

Ink wash drawing on paper

10¾ x 13½

was "born to the business," working first with his sculptor father who maintained a sculpture studio specializing in religious subjects. Zuñiga moved to Mexico in the 1930s, painting before and after his arrival, but adding woodcuts and wood engravings to his *oeuvre* around that time. He was affiliated with the School of Direct Carving in Mexico City and taught for many years at the School of Painting and Sculpture. While a number of sculptors were working with "modern" ideas, such as those of Brancusi and cubism (for

example, Luis Ortiz Monasterio), Zuñiga developed an indigenous style from Hispanic and pre-Hispanic traditions that is both modern and built on the monumentality of the Indian figure, almost exclusively female. Eschewing the "modernism" of European styles, Zuñiga in his own words focused on the "expression, the density, the intensity, and the interior movement of a figure."[37] With this mission, Zuñiga taught at the School of Painting and Sculpture between 1938 and 1970, and throughout his long career created many public monuments with a distinct personal style.

Zuñiga was also a master engraver, printmaker, and draftsman as well as a sculptor, although the two dimensional figures are completely interrelated with the monumental style of the sculpture. His lithographs, spanning the period 1972 through 1986, are much in demand as are his spectacular pastel and charcoal drawings. His drawing of four female figures entitled *Camino al Mercado* (see FIGURE 20, page 67) of 1984, repeated in variations in both sculpture and a lithograph, illustrates the "Zuñiga style" perfectly. The solidity and movement of the figures on the way to market who interact by passing the gossip of the day is alive with motion—high art derived from individuals captured in a commonplace, daily routine.

The romanticism of artists such as Corzas and Zuñiga is also part of the artist Rafael Coronel's (1931–) approach to art and draftsmanship. Much honored as an artist, Coronel is the husband of Diego Rivera's daughter, Ruth. His figures and portraits create, with strong base drawings, mystical characters, sometimes in historical costume and sometimes in the ordinary business of life. In the mixed media drawing *Niño* (see FIGURE 21, page 68), for example, Coronel develops a haunting portrait of a young man with a searing gaze and maturity that seems to belie his youth.

Many Mexican artists and sculptors have been "students" of Zuñiga or of his work. Felipe Castañeda (see his *Ofrenda*, FIGURE 22, page 69) is a fine example. Born in 1933 in Michoacan, Castañeda worked at the National Museum of Anthropology as Zuñiga's assistant, mastering the art of stone and bronze sculpture. His depictions, and those of another contemporary sculptor, Armando Amaya, follow unique artistic paths, however. Castañeda's work sometimes integrates "European" influences in addition to the indigenous figures such as are the subject of *La Ofrenda* of 1992. The styles of Zuñiga and contemporary artists such as Castañeda and Amaya and their approach to the human form have become emblematic of what many regard as a cohesive and ongoing "modern" Mexican style in sculpture.

[37] Francisco Zuñiga, "Vigencia de la figura humana," in *Francisco Zuñiga* (Mexico City: El Equilibrista and Instituto Nacional de Bellas Artes, 1994), 43 (from a lecture at the Academy of the Arts, 1987).

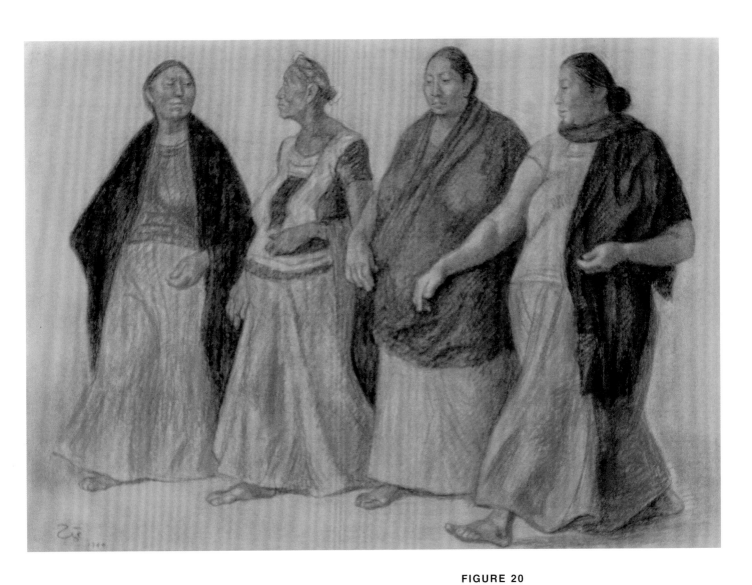

**FIGURE 20**

Francisco Zuñiga

*Camino al Mercado (Road to the Market)*, 1984

Pastel on Paper

19½ x 27

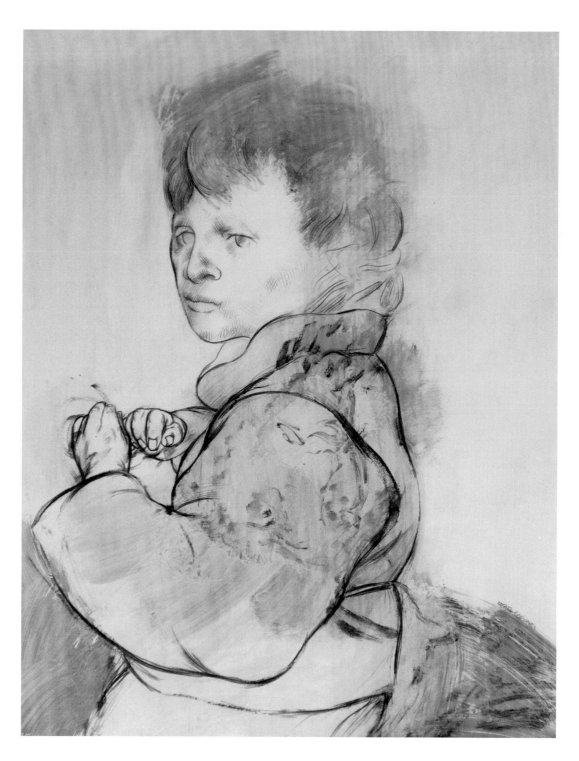

**FIGURE 21**

Rafael Coronel

*Niño (Young Boy)*, c. 1970

Pencil and mixed media drawing

28¼ x 22¼

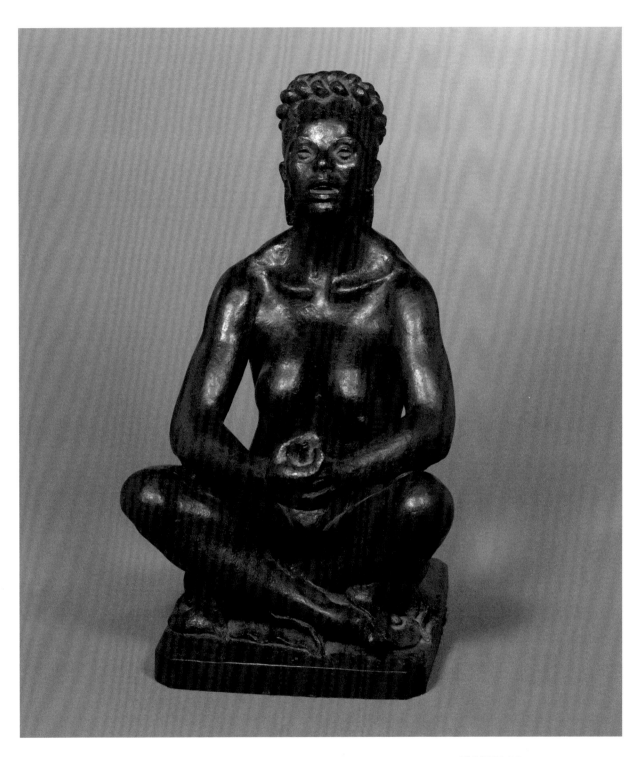

**FIGURE 22**

Felipe Castañeda

*La Ofrenda (The Offering)*, 1992

Bronze 3/7

17½h x 10¼w x 9d

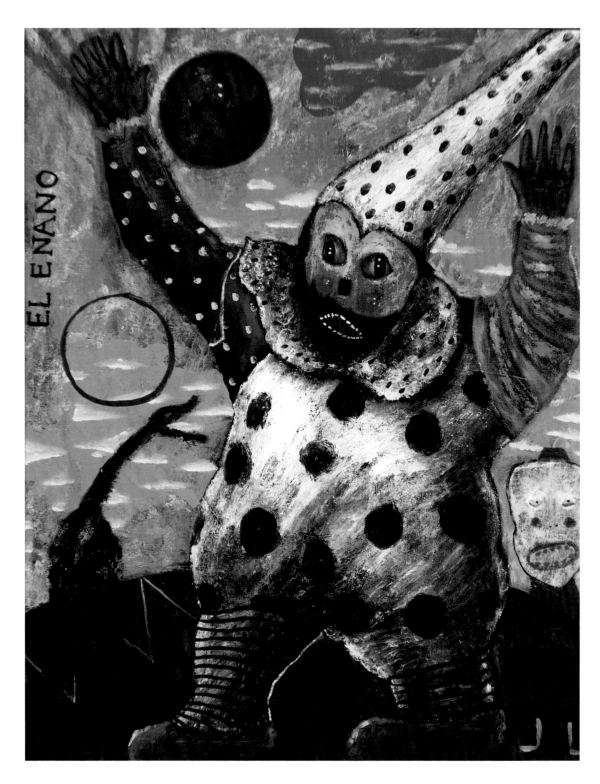

**FIGURE 23**

Alejandro Colunga

*El Enano y la Niña (The Dwarf and Young Girl)*, 1993

Oil on canvas with artist's frame

38 x 30

# Conclusion: Trends in Late Twentieth-Century Mexican Art

*T*he past is present in modern and contemporary Mexican art. The preponderance of a tragic spirit and the belief in the power of myth still takes on enormous significance in the art of contemporary Mexicans. The Oaxacan school, with Tamayo and a long artistic tradition as inspiration, and a host of other approaches exemplify the integration of magic and myth and in the animistic characteristics of pre-Columbian art.

Many artists live and work or originated in Oaxaca, including Francisco Toledo and Rodolfo Nieto. Toledo, born in 1940, is perhaps the most famous of contemporary Oaxacan artists. While he has lived all over the world, Toledo is most definitely identified as a Mexican artist, both in primary residence and in his transmutations of ancient Indian texts and pre-Columbian art and figures. Animals and insects almost exclusively occupy his brilliant, composed,

semi-surrealist creations that sometimes integrate figures in action with themes from world literature. In this anthropomorphic world, males and females of the animal kingdom exchange anatomies, strange beasts are composed of different parts of several animals and copulation is developed as an apparent and incessant symbol of creation. Toledo's enormous *oeuvre* in watercolor is supplemented by works in other media, including lithography. Toledo is a Spanish surname. However, the artist is of Zapotecan blood and was influenced by the Indian myths into which he was born and raised.

Rodolfo Nieto (1936–1985) is another fine example of the Oaxacan school. His formal education was supplemented with trips to Europe and most especially to Paris where he ultimately settled. With exhibitions and acclaim in Mexico and Europe, Nieto focused on a kind of modernism cum mythical animism. Animals take on human qualities in these pictorial and often highly colored creations. Some of the easel works are dark and brooding, however. His oil, entitled *Miedo en la Mariposa* (*Fear in the Butterfly*), probably painted late in the artist's career, is one of those works.

The influence of the kind of distilled "abstraction" typical of Tamayo is evident within the works of Oaxacan artists such as

Toledo and Nieto. Artists of the Oaxacan school have developed and are developing, through very individualistic stylistic influences and talents, an art that is both modern and primitive. (In the world of art, as in the world of ideas, there are really no "schools," only individuals). But this is not the only style that carries the claim "modern Mexican art." Many fine artists are working today in Mexico with unique and interesting styles. Names such as Alfredo Castañeda, Nahum Zenil, Ismael Vargas, Julio Galán, Dulce Maria Nuñez, Sergio Hernandez, and many others come to mind, most of them exhibiting a form of "personal surrealism." These talents would compete in originality and value with any art being produced around the world. There is not some *mechanical* use of myth, pre-Columbian mythology, and the Mexican penchant for tragedy and death that affects all these artists. However, these predilections from art and Mexican history have strongly affected most of them.

The mythology of the primitive affects some contemporary Mexican artists more than others. One artist who is among Mexico's most prominent contemporary painters is Alejandro Colunga, born in Guadalajara in 1948. In eerie and highly textural paintings of the fantastic, Colunga reveals his background as a circus performer and as an inheritor of a distinctly Mexican tradition. A self-taught artist and native of Guadalajara, Colunga's work surveys a whole range of pre-Columbian, Hispanic, and mythological subjects. Virgins, devils, dwarfs, magicians, magical animals, and demonic clowns people his large-scale works. The circus and clowns in particular, fascinate Colunga as they did Mexicans and Mexican artists (consider Posada's and Orozco's prints, for example) throughout the century. Colunga is not, of course, the first artist to use the circus and circus performers as a metaphor for the human condition. The fascination with these performers as part of the "drama of life" intrigued many artists as diverse as Picasso and the American artist, Walt Kuhn. But in Colunga's hands, a fantastic and (often) demonic cast is given his characters. For example, a work entitled *El Enano y la Niña* (see FIGURE 23, page 70) of 1993, focuses on the horrific qualities of a dwarf clown frightening a little girl with a strange black animal (a goose?) thrown in to boot. Even more demonic in appearance is Colunga's sculpture, where circus parades and male witches are presented in hieratic or iconographic reference. His "fish man," *Hombre de Peces* (see FIGURE 24, page 73), whose entire body, multiple feet, and headdress are composed of fish — sculpted as resembling a part of the male anatomy — is a fantastic kind of animism. This "art of the fantastic" is a feature of the continuous enrichment of contemporary Mexican art.

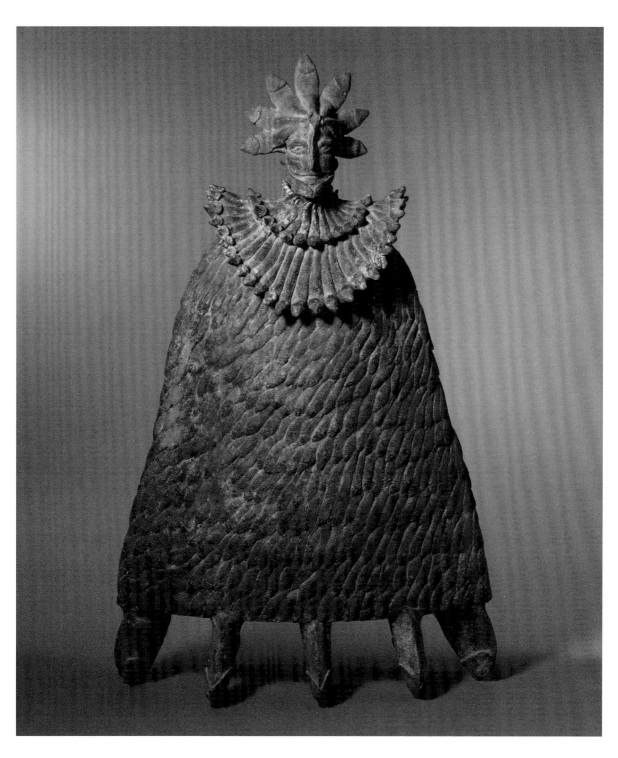

**FIGURE 24**

Alejandro Colunga

*Hombre de Peces (Fish Man)*, c. 1985

Terra cotta

27½h x 19w x 8d

**FIGURE 25**

*Papier-mâché Skull*, Mexican folk art, c. 1990s

Layered paper

9h x 8½w x 5d

Political, economic, and social influences changed much in Mexico over the twentieth century. The entire skein of artistic expression underwent a sea of change. Moreover, the course of Mexican art of the twentieth century could not be explained in isolation. No art can be explained in this manner. But no artist of *any* nationality or in any particular setting is immune from a symphony of influences, including cultural history. The *internal* impact of Mexican culture, including myth, religion, and the "terror of Mexican history," were and are a critical element in interpreting the course and direction of high art in Mexico. We have argued, in effect, that these influences are so strong even in the present day that it is generally possible to use the adjective *Mexican* when describing the rich heritage of artists living in and influenced by Mexican culture.

Nowhere, perhaps, has that influence remained stronger than on the folk art of Mexico, where Calaveras and (thankfully) milder forms of death rituals still play a critical role in popular and high artistic culture. Posada's *calaveras* ("Catrina" and others) are reproduced everywhere in low and grand artistry and brilliant Mexican folk art is brought to bear on the theme of death (see the elaborate paper skull in FIGURE 25, page 74). In this art, time is circular, dualism reigns, religion and magic co-exist and death is, in part, a matter for irony and playfulness. Mexican art would not be decipherable apart from these elements. These factors demonstrate the power of myth in popular culture and, not less, in the high and passionately beautiful traditions that artists created in the twentieth century and continue to create in the new millennium.

Alcantara, Isabel and Sandra Egnolff. *Frida Kahlo and Diego Rivera.* Munich: Prestel Verlag, 1999.

Associated American Artists. *Rufino Tamayo: 17 Years at Mixografia Workshop,* 1974–91. New York: Mexican Cultural Institute, 1993.

———. *Rufino Tamayo: Works from the Museo Rufino Tamayo, The Instituto Nacional de Bellas Artes, and Private Collections.* New York: Mexican Cultural Institute, 1994.

Berdecio, Roberto and Stanley Appelbaum, eds. *Posada's Popular Mexican Prints.* New York: Dover Publications, 1972.

Billeter, Erika, ed. *Images of Mexico: The Contribution of Mexico to 20th Century Art.* Dallas: Dallas Museum of Art, 1988.

———. *The Blue House: The World of Frida Kahlo.* Houston: The Museum of Fine Arts, 1993.

Brewster, Jerry. *Zuñiga: The Complete Graphics, 1972–1984.* New York: Alpine Fine Arts Collection, Inc., 1984.

Cancel, Luis R., Jacinto Quirarte, Marimar Benitez, Nelly Perazzo, Lowery S. Sims, Eva Cockcroft, Felix Angel, and Carla Stellweg. *The Latin American Spirit: Art and Artists in the United States, 1920–1970.* New York: Harry N. Abrams, Inc., 1988.

Cardoza y Aragon, Luis. *Carlos Merida: Color y Forma.* Mexico City: Galeria Coleccion de Arte Mexicano, 1992.

Center for Inter-American Relations. *Carlos Merida: Graphic Work, 1915–1981.* New York: Center for Inter-American Relations, 1981.

Chadwick, Whitney. "El Mundo Mágico: Leonora Carrington's Enchanted Garden," in *Leonora Carrington, the Mexican Years, 1943–1985.* San Francisco: The Mexican Museum, 1991.

———. *Leonora Carrington: La Realidad de la Imaginacion.* Mexico City: Consejo Nacional para la Cultura y Las Artes, 1994.

Chase, Stuart. *Mexico: A Study of Two Americas.* New York: The Macmillan Company, 1933.

Chavez, Augustin Velazquez. *Contemporary Mexican Artists.* New York: Covici Friede, 1937.

Cockcroft, Eva. "The United States and Socially Concerned Latin American Art: 1920–1970," in Cancel et al., *The Latin American Spirit.* New York: Harry N. Abrams, Inc., 1988.

Colle, Marie-Pierre. *Latin American Artists in Their Studios.* New York: The Vendome Press, 1994.

Cuevas, José Luis. *José Luis Cuevas: Self-Portrait with Model,* Introduction by José Gómez-Sicre. New York: Rizzoli, 1983.

Diamond, Jared. *Guns, Germs, and Steel: The Fates of Human Societies.* New York: W. W. Norton, 1999.

Diaz de Cossio, Roger. ed. *Carlos Mérida, su obra en el multifamiliar Juárez, nacimiento, muerte y resurreccion.* Mexico City: ISSSTE, 1988.

Day, Holliday T. and Hollister Sturges. *Art of the Fantastic: Latin America, 1920–1987.* Indianapolis: Indianapolis Museum of Art, 1987.

Favela, Ramon. *Diego Rivera, the Cubist Years.* Phoenix: Phoenix Art Museum, 1984.

Fehrenbach, T. R. *Fire and Blood: A History of Mexico.* New York: Da Capo Press, 1995.

Founders Society Detroit Institute of Arts. *Diego Rivera: A Retrospective.* New York: W. W. Norton, 1986.

Fuentes, Carlos with commentaries by Sarah M. Lowe. *The Diary of Frida Kahlo: An Intimate self-portrait.* New York: Harry N. Abrams, 1995.

Galeria Arvil. *Fantastic Zoology, Toledo-Borges.* Mexico City: Prisma Editorial, 2003.

Galeria Misrachi. *Siqueiros.* Introducción de Enrique Gual, with English trans. by Emma Gutierrez Suarez. Mexico City: Galeria de Arte Misrachi, 1965.

Goldman, Shifra M. *Contemporary Mexican Painting in a Time of Change.* Albuquerque: University of New Mexico Press, 1991.

Guggenheim, Solomon R. Foundation. *Rufino Tamayo: Myth and Magic.* New York: Eastern Press, 1979.

Haab, Armin. *Mexican Graphic Art.* New York: George Wittenborn, Inc., 1957.

Hamill, Pete. *Diego Rivera.* New York: Harry Abrams, 1999.

Helm, MacKinley. *Modern Mexican Painters: Rivera, Orozco, Siqueiros and Other Artists of the Social Realist School.* Reprint, New York: Dover Publications, 1941.

———. *Man of Fire: J. C. Orozco.* New York: Harcourt, Brace, 1953.

Instituto Nacional de Bellas Artes. *Francisco Zuñiga.* Mexico City: Ediciones del Equilibrista and Turner Libros, 1994.

Lewin Galleries. *Carlos Merida: A Retrospective.* Beverly Hills: Lewin Galleries, n.d.

———. *Diego Rivera: Sketch Book,* dedicated to Frieda Kahlo and inherited by Ruth Rivera. Palm Springs: Lewin Galleries, n.d.

———. *Rufino Tamayo: 23 Color Plates of Handmade Paper Mixographs.* Palm Springs: Lewin Galleries, n.d.

———. *Diego Rivera: A Rare Retrospective Exhibition.* San Bernadino: Act 1 Publishing, 1993.

Littleton, Taylor D. *The Color of Silver: William Spratling, His Life and Art.* Baton Rouge: Louisiana State University Press, 2000.

Marnham, Patrick. *Dreaming with His Eyes Open: A Life of Diego Rivera.* New York: Alfred A. Knopf, 1999.

Mexican Museum. *Leonora Carrington: The Mexican Years, 1943–1985.* San Francisco: The Mexican Museum, 1991.

Museum of Modern Art. *Diego Rivera Exhibition Catalogue.* New York: Arno Press, 1931, reprint 1971.

Newhall, Edith. "The Culture Business: Latin's Lovers." *New York Magazine.* May 20, 1996: 34–35.

Orozco, José Clemente. *Obras de Clemente Orozco en la Coleccion Carrillo Gil*, Catalogo y Notas de Justino Fernandez. Mexico City: 1949.

———. *Catalogo Completo de la Obra Grafica de Orozco*, Luigi Marrozzini, ed. San Juan: Instituto de Cultura Puertorriquena, Universidad de Puerto Rico, 970.

———. *Orozco* Introduction by Alma Reed. New York: Hacker Art Books, 1985.

———. *An Autobiography.* Trans. by Robert C. Stephenson. Mineola, NY: Dover Publications, 2001, 1962.

Ovalle, Ricardo, Walter Gruen, Alberto Blanco, Teresa del Conde, Salomon Grimberg, and Janet A. Kaplan. *Remedios Varo, Catalogo Razonado* Mexico, D.F.: Ediciones Era, 1994.

Page, Amy. "Latin Rhythm," *Art & Auction.* January 20, 1998: 72–75, 114.

Paz, Octavio. *Essays on Mexican Art.* Trans. by Helen Lane. New York: Harcourt Brace, 1993.

——— and Jacques Lassaigne. *Rufino Tamayo.* Mexico City: Edicione Poligrafa, 1995.

Pellicer, Carlos and Rafael Carrillo Azpeitia. Mural *Painting of the Mexican Revolution.* Mexico City: Fondo Editorial de la Plastica Mexicana, 1992.

Rasmussen, Waldo, Fatima Bercht, and Elizabeth Ferrer, eds. *Latin American Artists of the Twentieth Century.* New York: Harry N. Abrams, for the Museum of Modern Art, 1993.

Riestra, Jaime and Patricia Ortiz Monasterio. New *Moments in Mexican Art.* Madrid: Turner Libros, 1990.

Rivera, Diego. *Portrait of America*, with an explanatory text by Bertrand Wolf. New York: Covici Friede, 1934.

Rochfort, Desmond. *Mexican Muralists: Orozco, Rivera, Siqueiros.* New York: Universe Publishing, 1993.

Saunders, Fenella. "Tuning in To Sacred Sounds," *Discover.* March 2003: 13.

Schmeckerier, Laurence E. *Modern Mexican Art.* Minneapolis: University of Minnesota Press, 1939.

Tattersall, Ian. *The Last Neanderthal: The Rise, Success, and Mysterious Extinction of Our Closest Human Relatives.* New York: Macmillan, 1995.

Wolfe, Bertrand. *The Fabulous Life of Diego Rivera.* New York: Stein and Day, 1939, 1963.

Zuñiga, Francisco. *Catalogue Raisonné, Vol. 1, Sculpture, 1923–1993.* Mexico City: Albedrio in association with Fundación Zuñiga Laborde, A.C., 1999.

———. *Catalogue Raisonné, Vol. II, Oil Paintings, Prints & Reproductions, 1927–1986*, with texts by Ariel Zuñiga and Andrew Vlady. Mexico City: Albedrio in association with Fundación Zuñiga Laborde, A.C., 1999.

# EXHIBITION CHECKLIST38

1. *Pre-Columbian Dog Effigy*
   c. 200 BC – AD 300
   Molded terra cotta
   Colima culture (West Coast)
   7¼h x 7w x 12¾d
   **FIGURE 1**

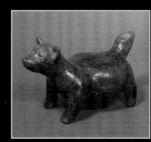

2. *Pre-Columbian Male and Female Figures*
   100 BC – AD 250
   Terra cotta
   Nayarit Culture (West Mexican, Protoclassic)
   9½h x 9w x 4d

3. José Guadalupe Posada
   *El Testerazo del Diablo,* c. 1900–1910
   Zinc etching
   5¼ x 3¼

4. José Guadalupe Posada
   *Don Perabel,* c. 1900–1910
   Zinc etching
   5¼ x 3¼

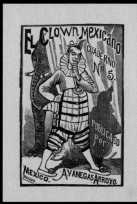

5. José Guadalupe Posada
   *El Clown Mexicano,* c. 1900–1910
   Zinc etching
   5¼ x 3¼
   **FIGURE 2**

6. José Guadalupe Posada
   *To Die Dreaming,* c. 1900–1910
   Zinc etching
   5¼ x 3¼

[38] All sizes of two-dimensional images are measured
height by width (in inches).

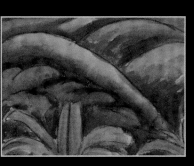

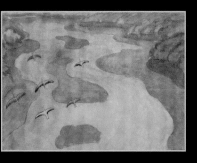

7. Diego Rivera
   *Forest, Tehuantepec,* 1928
   Watercolor on rice paper
   5¾ x 8
   **FIGURE 3**

8. Diego Rivera
   *Flower Market,* 1930
   Lithograph on yellow tinted paper
   11 x 15¾

9. Diego Rivera
   *Yucatan,* 1930–1931
   Watercolor on rice paper
   12 x 16
   **FIGURE 4**

10. Diego Rivera
    *Sueño (Sleep),* 1932
    Lithograph on paper
    16 x 12
    **FIGURE 5**

11. Diego Rivera
    *Self-Portrait,* 1930
    Lithograph on paper
    14⅞ x 11⁵⁄₁₆

12. José Clemente Orozco
    *La Pulqueria (Masked Dancers),* 1928
    Lithograph on paper
    13 x 16¼

13. José Clemente Orozco
    *Head of Woman (La Chata),* 1935
    Drypoint
    13 x 16¼

14. José Clemente Orozco
*Prometheus*, 1935
Drypoint
6½ x 8⅞

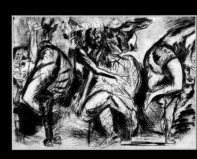

15. José Clemente Orozco
*Contorsionistas (Contortionists)*, 1944
Etching and aquatint
11¹⁵⁄₁₆ x 17½
**FIGURE 6**

16. José Clemente Orozco
*Female Nude*, c. 1945–1946
Gouache on paper
22 x 16½
**FIGURE 7**

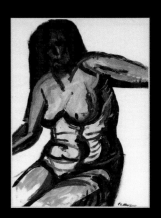

17. David Alfaro Siqueiros
*Jesusito Sera un Santo
(Little Jesus will be a Saint)*, c. 1960
Color lithograph on paper
21 x 15½
**FIGURE 8**

18. David Alfaro Siqueiros
*Nostalgia for Liberty*, 1966
Oil on board.
12½ x 10
**FIGURE 9**

19. José Clemente Orozco
*Desempleados (Out of Work)*, 1932
Lithograph on paper
15 x 11

20. Pablo (Paul) O'Higgins
*Rights of the Ruling Class*, 1946
Woodcut
10 x 9½

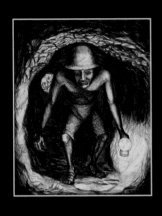

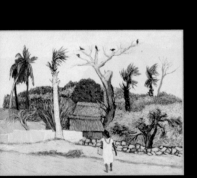

21. Alfredo Zalce
*They Came Down the Avenue*, c. 1945–1946
Lithograph on paper
15½ x 11½

22. Alfredo Zalce
*The Revolutionary*, 1946
Linocut
12¾ x 18¾

23. Leopoldo Mendez
*The Revolutionary*, 1946–1947
Lithograph on paper
15⅞ x 20

24. Francisco Mora
*Miner*, 1947
Lithograph on paper
14¾ x 12
**FIGURE 10**

25. Pablo (Paul) O'Higgins
*Peasant Drinking Water*, 1955
Oil on canvas
29½ x 20¼

26. Alfredo Zalce
*Paisaje de Yucatan*, 1946
Gouache on paper
19 x 25½
**FIGURE 11**

27. Rufino Tamayo
*Cabeza en Negra*, 1978
Mixografia (mixed media) on handmade paper
33 x 25

28. Rufino Tamayo
    *Protesta*, 1983
    Mixografia (mixed media) on handmade paper
    39 x 31

29. Rufino Tamayo
    *Personajes con Pajáros (People with Birds)*, 1988
    Mixografia (mixed media) on handmade paper
    43 x 35
    **FIGURE 12**

30. Rufino Tamayo
    *Sandias (Watermelons)*, c. 1970
    Mixografia (mixed media) on handmade paper
    29¾ x 22⅝
    **FIGURE 13**

31. Rufino Tamayo
    *Perro Aullando a la Luna*
    *(Dog Howling at the Moon)*, c. 1950
    Color lithograph on paper
    17¾ x 22
    **FIGURE 14**

32. Leonora Carrington
    *The Bird Feeder*, 1960
    Ink drawing
    8¾ x 10
    **FIGURE 15**

33. Leonora Carrington
    *Tuesday*, 1987
    Color lithograph on paper
    22 x 34

34. José Luis Cuevas
    *Secret of Sir Walter Raleigh*, 1971
    Ink and watercolor on paper
    10¼ x 7

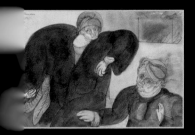

35. José Luis Cuevas
*El Bruno and His Mother*, 1976
Ink and watercolor on paper
11¼ x 18
**FIGURE 16**

36. José Luis Cuevas
*L'amour Fou*, 1968
Lithograph on paper from "Crime Suite"
21½ x 29

37. Carlos Merida
*Construction in Red*, 1968
Oil on board
14¾ x 10½
**FIGURE 17**

38. Carlos Merida
*Abstract Sculpture*, c. 1970s
Bronze 3/3
8h x 10w x 3d

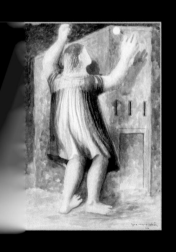

39. Jesus Guerrero-Galvan
*Girl Enchanted by Beam of Light*, 1939
Watercolor on paper
18 x 12¾
**FIGURE 18**

40. Jesus Guerrero-Galvan
*Woman*, 1935
Pencil drawing
16¾ x 12

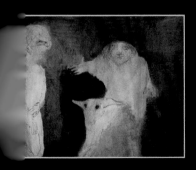

41. Francisco Corzas
Untitled, 1963
Ink wash drawing on paper
10¾ x 13½
**FIGURE 19**

42. Francisco Zuñiga
    *Camino al Mercado (Road to the Market)*, 1984
    Pastel on paper
    19½ x 27
    **FIGURE 20**

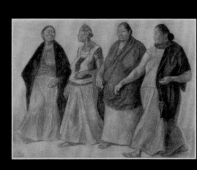

43. Francisco Zuñiga
    *Tendederos*, 1975
    Pastel on paper
    19½ x 25¾

44. Rafael Coronel
    *Niño (Young Boy)*, c. 1970
    Pencil and mixed media drawing
    28¼ x 22¼
    **FIGURE 21**

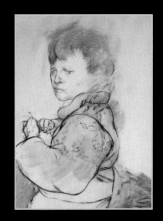

45. Luis Ortiz Monasterio
    *Cubist Bust of Woman*, 1952
    Terra cotta 2/25
    12⅛ h x 9⅜ w x 6½ d

46. Felipe Castañeda
    *La Ofrenda (The Offering)*, 1992
    Bronze 3/7
    17½ h x 10¼ w x 9 d
    **FIGURE 22**

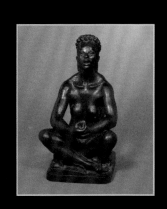

47. Francisco Toledo
    *La Hoja (The Leaf)*, 1984
    Color lithograph on paper
    18¾ x 24½

48. Rodolfo Nieto
    *Miedo en la Mariposa (Fear in the Butterfly)*, 1980
    Oil on canvas
    29 x 23½

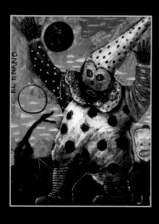

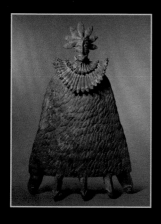

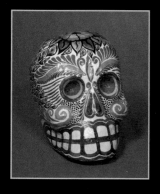

49. Alejandro Colunga
    *El Enano y la Niña (The Dwarf and Young Girl)*, 1993
    Oil on canvas with artist's frame
    38 x 30
    **FIGURE 23**

50. Alejandro Colunga
    *Hombre de Peces (Fish Man)*, c. 1985
    Terra cotta
    27½ h x 19w x 8d
    **FIGURE 24**

51. *Papier-mâché Skull*
    Mexican folk art, c. 1990s
    Layered paper
    9h x 8½w x 5d
    **FIGURE 25**

52. *"Fine Lady" Calaveras*
    Mexican folk art, c. 1990s
    Terra cotta
    15½ h x 10½ w x 5½ d

**Also, 3 unnumbered vintage photographs of
Diego Rivera and Frieda Kahlo
by Guillermo Zamora:**

*Diego Rivera Portrait*

*Diego Rivera Painting Portrait of Doloros Olmedo*

*Diego Rivera and Frieda Kahlo in Courtyard of Casa Azul*